IMAGES
of America

LAFAYETTE SQUARE

ST. LOUIS

LAFAYETTE PARK
ST LOUIS, MO.

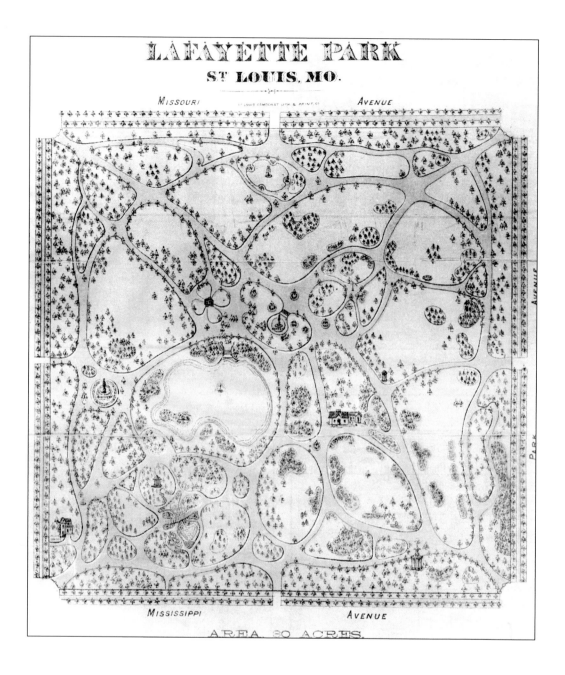

MISSOURI AVENUE

MISSISSIPPI AVENUE

AREA 30 ACRES.

IMAGES
of America

LAFAYETTE SQUARE
St. Louis

Albert Montesi
and Richard Deposki

ARCADIA
PUBLISHING

Published by Arcadia Publishing
Charleston, South Carolina

Printed in the United States of America

Library of Congress Catalog Card Number: 99-61839

For all general information contact Arcadia Publishing at:
Telephone 843-853-2070
Fax 843-853-0044
E-mail sales@arcadiapublishing.com
For customer service and orders:
Toll-Free 1-888-313-2665

Visit us on the Internet at www.arcadiapublishing.com

CONTENTS

ACKNOWLEDGMENTS

I would like to thank the following persons and institutions who provided such great help in the making of this book: David Beecher, Tom Danisi, Tom Keay, Jeffery Aytes, Tim and Therese Becker, Jim and Elaine Barry, Ruth Kamphoefner, and a host of others who helped immeasurably.

INTRODUCTION

Before stepping into the circumambient ooze that swirls through the life and times of Lafayette Square, a neighborhood that extends far back in St. Louis history, we would like to pause to consider why a once fashionable neighborhood that went through a frightful decline after a disastrous cyclone has now grown into a St. Louis icon.

Each Christmas and spring thousands of St. Louisians crowd into this 325-acre neighborhood with its central park to examine how well its citizens have tackled the awesome task of restoration. One may well ask: Do these crowds come determined to seek out St. Louis' once opulent past? Or do they hope to glimpse how a once stately neighborhood withstood the commercial ravages of time? Or is it to witness how a brave group of people overcame decline to recreate a memorable part of St. Louis history? Or is it simply that they seek the order and serenity of the Victorian past?

To search out these answers, it would do well to look at the history of Lafayette Square.

In the early nineteenth century, the village community of St. Louis was nestled comfortably on the cusp of the Mississippi. To the south of this small township lay lands set aside for the pasturing and herding of cattle. These "Commons" were later to be converted into a neighborhood that would soon be designated Lafayette Square.

In 1835, city officials sparked by then mayor John F. Darby and Board of Aldermen President Colonel Thornton Grimsley offered these acres for sale as home sites to the public at large. Later, in order to attract buyers, the pair decreed by ordinance that 30 acres of these lands be devoted to a park, which was to be bound by four 100-foot wide streets. This park, in time called Lafayette Park, was later to become the grand center of the most fashionable neighborhood to grow from the great economic expansion of St. Louis before and after the Civil War.

Since space is limited here, it would be best to roughly sketch out certain dates that were important in the rise and decline of this ancient neighborhood.

Let us briefly imagine an elevated area that overlooked the central town from a distant hill. As early as 1836, the first plat of this desirable real estate was sold. Its buyers were generally an affluent group who wished for a pastoral retreat from the small city. During the next decade, 1840–1850, the population of the city grew fourfold, quadrupling itself in ten years. During this time, the Square grew enormously. After construction had stopped during the Civil War, the next decade saw most of the houses facing the park erected. In 1866 Montgomery Blair, postmaster general under President Lincoln, plated Benton Place, one of the major streets treated in the book. Julius Pitzman was selected as the designer of this private enclave, with

an oval parkway bisecting its circular roadway. From 1865 to 1896, Lafayette Park, under the directorship of various landscape superintendents, became a horticultural showcase and the city's first recreational area. In 1869, an ornate iron fence was erected at great expense to enclose the then fashionable park. In 1868, Harriet Hosmer's Thomas Hart Benton statue was unveiled to an audience of some 40,000 St. Louisians who crowded into the park; in 1869, a bronze replica of Houdon's George Washington was erected in the park; and in 1870, major improvements occurred in Lafayette Park. It was enlarged with gazebos, bandstands, an aquarium, and a boathouse. On May 27, 1896, a destructive cyclone swept through the area and destroyed almost all of its foliage and buildings, with the single exception being the statue of Benton, which stood. After this tragedy many of the homeowners fled to the Central West End. By the time of the World's Fair in 1904, the Square had recovered somewhat; however, this recovery was brief, and in a short time the area lost its fashionable image and became a series of boardinghouses for the working man.

Its decay continued during the Depression and World War II. During these years its stately houses became filled with the impoverished folk of the city. Property fell into decline as the once elegant area became known as "Slum D," a pocket ghetto of the unfortunate and the poor. In 1945, John Albury Bryan, an architect and historian, purchased #21 on Benton Place. From this residence he fought a fierce and lonely battle to renovate and restore the Square.

By degrees during the 1960s and '70s, his wishes became reality. During this period, a handful of daring folk moved in and organized as the Lafayette Restoration Committee. They began a campaign to restore the area, determined to rehabilitate all of its old buildings to some of their past elegance.

This book is our attempt to describe how all of this took place, and to answer the questions raised in the beginning of the introduction.

One

BEGINNINGS

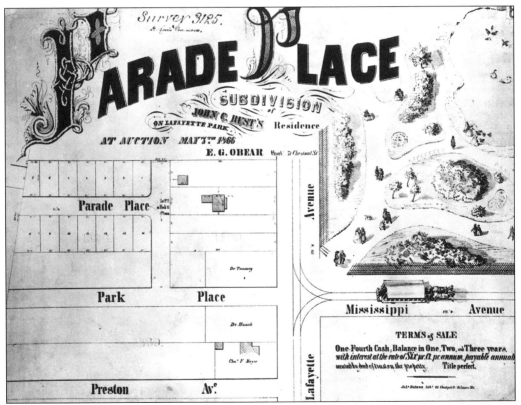

In an attempt to entice property buyers, this 1866 ad grandly proclaims the advantages of living in Lafayette Square. Not only does it map out its gracious streets and available sites for sale, but it also pictures a commodious way of transportation (a horse-drawn streetcar at the bottom of the page) and the presence of the fine park itself.

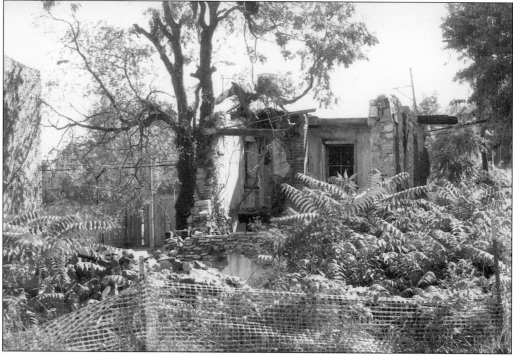

Pictured here are the ruins of one of the first buildings to be erected in the then wooded area of Lafayette Square. An isolated farmhouse, it was built sometime in 1778.

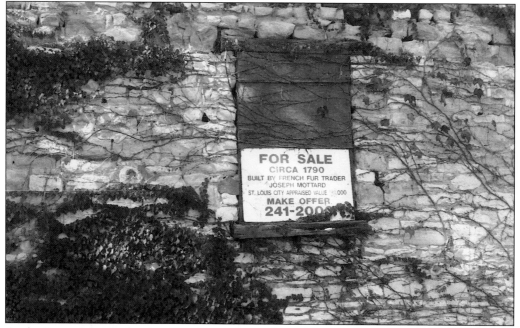

As the Square's local historian, Tom Danisi has indicated the records are not particularly clear as to who may have owned this very early structure. As this photo demonstrates, this stone house is in the process of being restored. The "For Sale" sign invites any buyer who would be so industrious and painstaking that he would restore this old farmhouse to its original appearance.

10

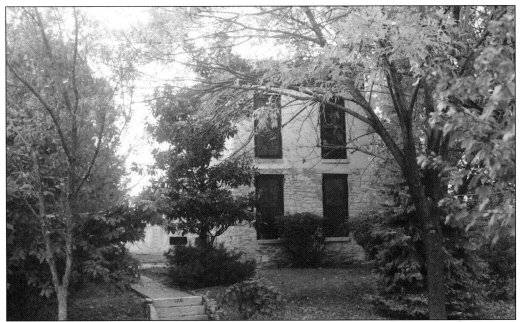

A full view of 1231 Mackay reveals most of the original stone structure of this ancient building. Erected sometime before 1790, it served as a storage area for a wealthy landowner named Joseph Motrand. Motrand used the building not only to house the produce and grain of his large tract, but also to shelter barn animals.

Erected as an out building on a vast plantation, 1231 is said to be the oldest standing structure in the entire city. Its present owner has heroically renovated it despite its tumultuous and destructive past.

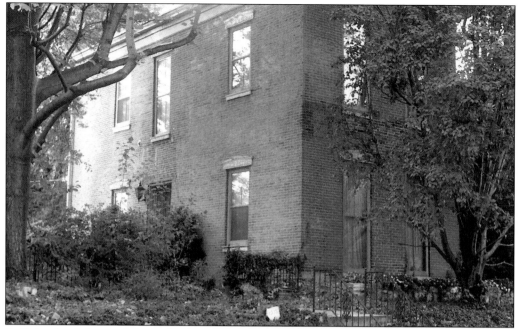

Built in the fashion of the Federalist style, which embodied neo-classical lines, 1225 Mackay is one of the oldest buildings in the Square. The house faces Park Avenue, perhaps indicating at one time that the land now filled with buildings in front of it was this house's front yard. William Page, a wealthy landowner, built it in 1853.

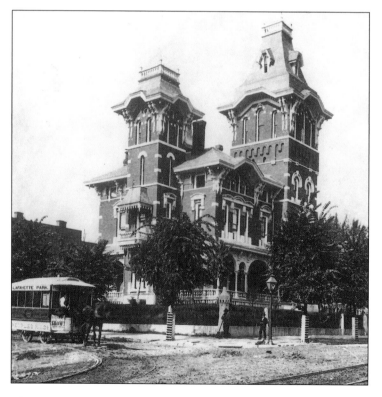

This ornate and elaborately constructed building in downtown St. Louis has a striking presence; however, the interesting aspect of this photo is the mule-drawn streetcar marked Lafayette Square, which delivered passengers directly to the Park.

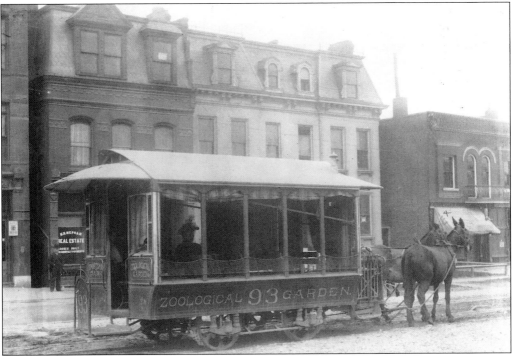

This was the last of the mule-drawn streetcars. It was small, drawn by bobtail mules, and leisurely slow. It was soon replaced by quicker and more reliable electrical and mechanical conveyances, innovations of the future.

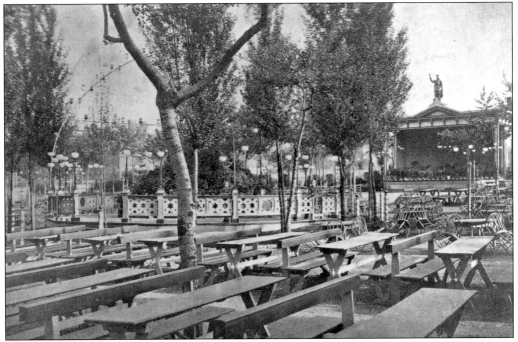

Schneider's Garden was an elaborate beer and wine garden located north of Benton Place. It featured a cave, a music stand, and one of the most popular bar restaurants of the day.

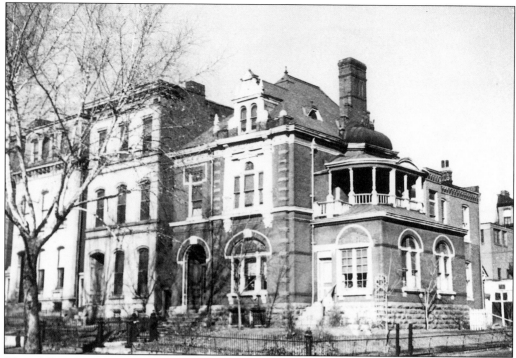

This elaborate Victorian structure embodies characteristics that a later generation will dub a distasteful gingerbread.

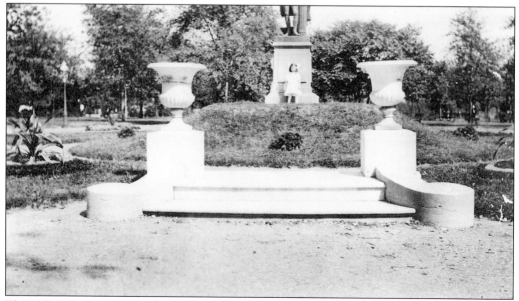

This Victorian practice of elaborate decoration is carried through here at the base of a local statue.

Two

GROWTH AND
DEVELOPMENT

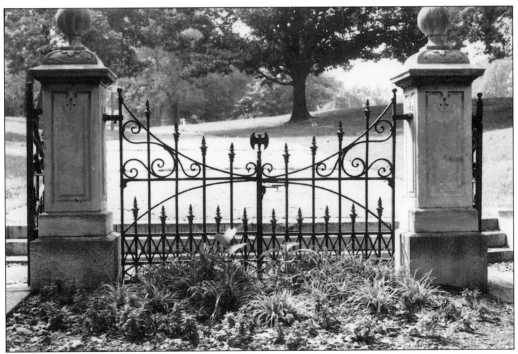

Shown here is one of the elaborate gates marking the northern entrance to Lafayette Park. This park became the most popular playground of the day. Through these gates poured thousands of people in order to enjoy the pleasures of the park, which included taking a swan boat or listening to a band concert or walking about with friends. It was St. Louis' first cultural center.

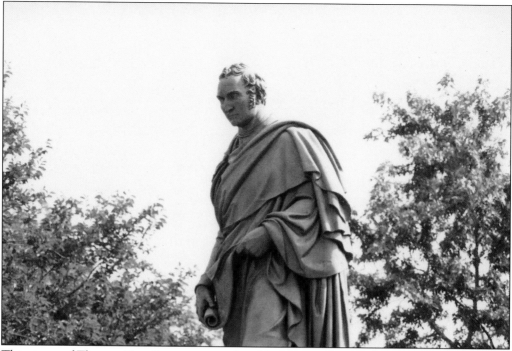

This statue of Thomas Hart Benton was sculpted by Harriet Hosmer. The unveiling in 1869 by the senator's daughter was attended by 40,000 spectators.

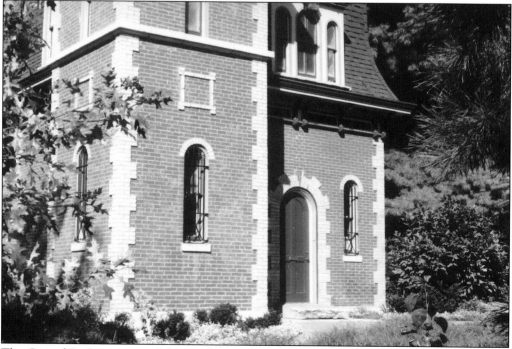

The City of St. Louis erected the southeast room of the Park House in 1866. In 1870, it was remodeled and expanded as a police station to oversee the vast crowds. It was renovated again in 1993.

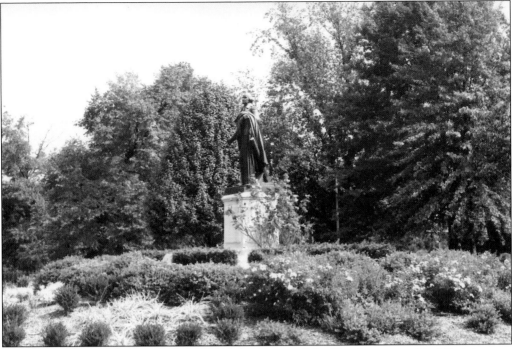

This statue, unveiled in 1869, is one of the five copies of the Houdon original in Virginia.

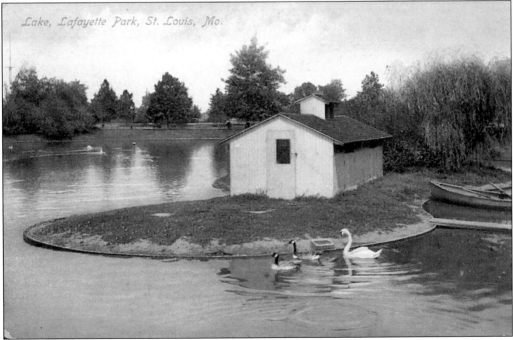

One of the attractions of the park was a central lake on which swan boating occurred. The lake was filled with ducks, geese, swans, and other fowl. Pictured here is a nineteenth-century duck house built in the middle of the lake on a small island that has been erected.

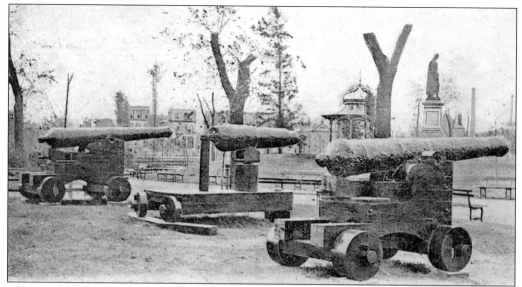

These cannons from an English frigate, drowned during the American Revolution, were given to the City of St. Louis by the City of Charleston. They were recovered from the bottom of Charleston Harbor.

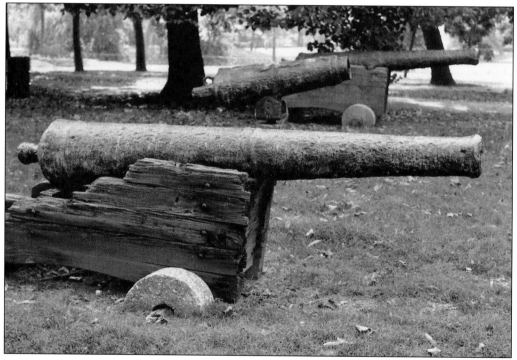

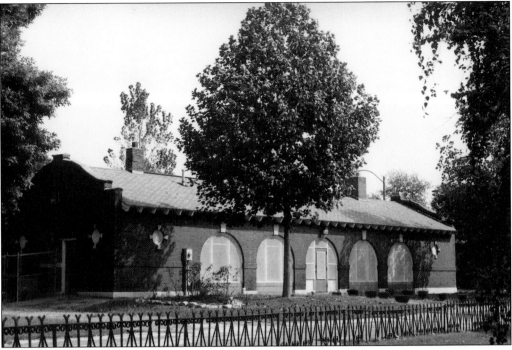

It was at the park's boathouse that visitors could hire these graceful swan boats to entertain a sweetheart or a friend on a warm summer afternoon, for the park's coolness attracted many during the summer months.

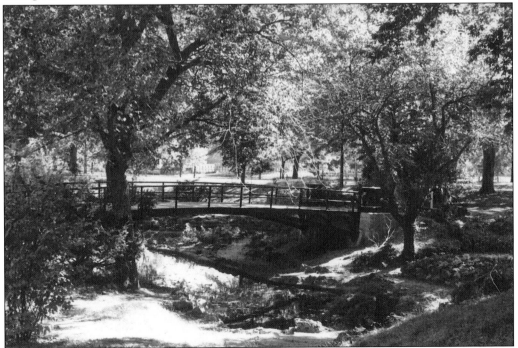

Patterned after a European model, the Grotto and its central lagoon became a meeting place for the strollers in the park.

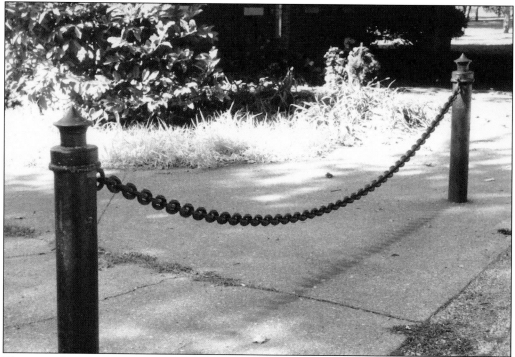

This iron chain erected in front of the small police station was used as an early barrier to keep outsiders from the vicinity of the police station.

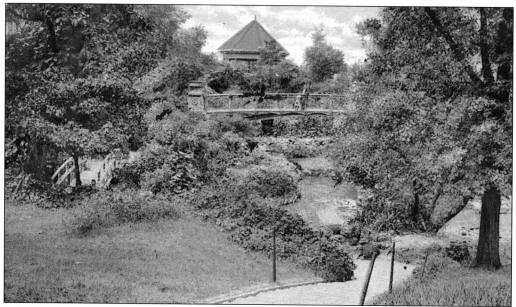

A 1904 postcard depicts the horticultural wonders of the park at that time. Note the small bridge on the left, which has since been covered over.

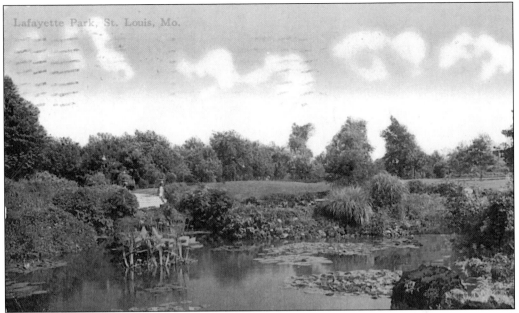

A 1904 postcard depicts the lagoon under the Rockery Bridge and the profuse plant life that grew there.

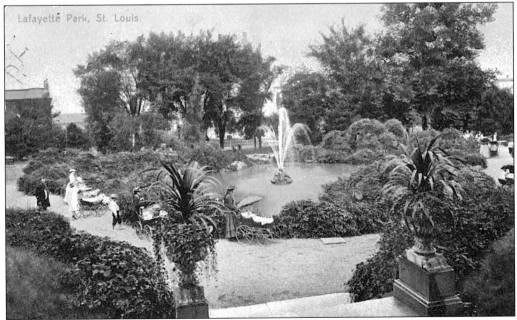

Another 1904 postcard depicts the Park's lake, fountain, and the various trees and plants surrounding it. The walkway shown remains the very same to date, with folks exercising their dogs, and others taking leisurely strolls.

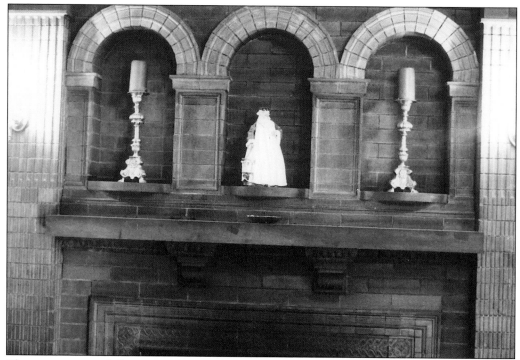

These are some artfully arranged pieces decorating the mantle above a Victorian fireplace.

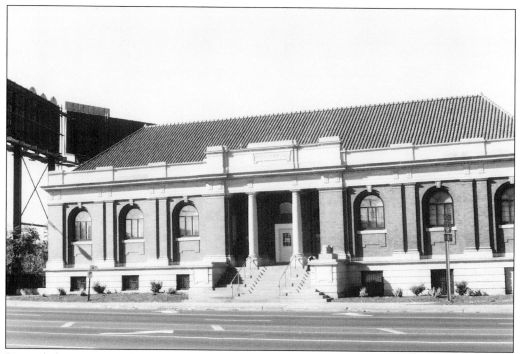

Part of the progress that the Lafayette Square community produced was the erection of this stately library.

Three

VICTORIAN
PERSONAL LIFE

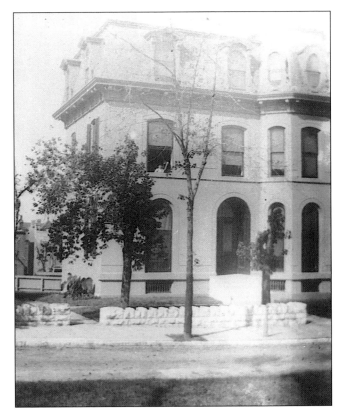

Pictured here is the home of
the Rainwater family, who
presided at 21 Benton Place as it
appeared in 1890.

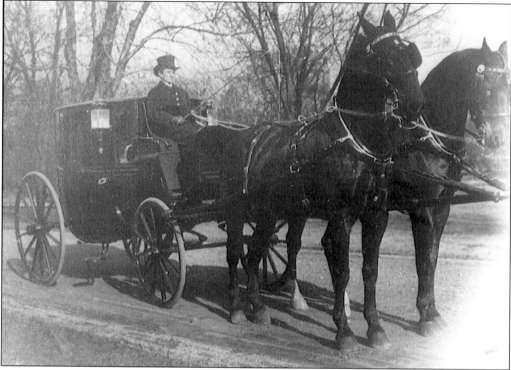

Mr. and Mrs. C.C. Rainwater of 21 Benton Place used this formal carriage for important social events.

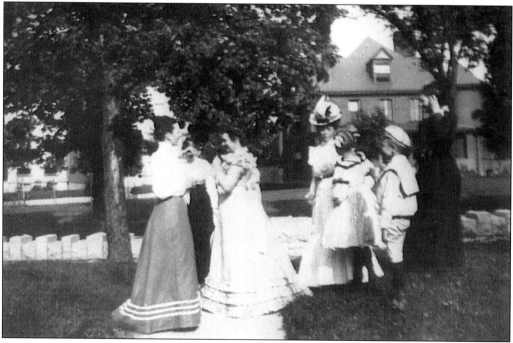

Rainwater nieces and nephews are pictured in the front yard of 21 Benton Place. Notice the sailor-boy clothing and the long dresses that were characteristic of the period.

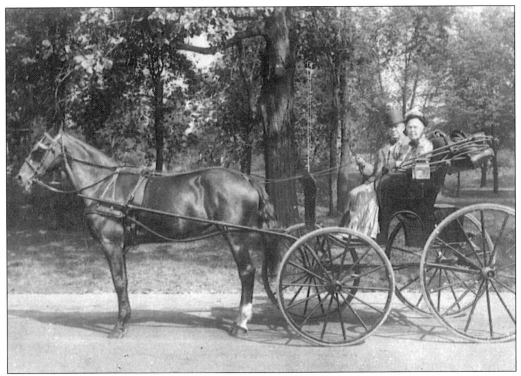

Mr. and Mrs. C.C. Rainwater are pictured in their everyday carriage.

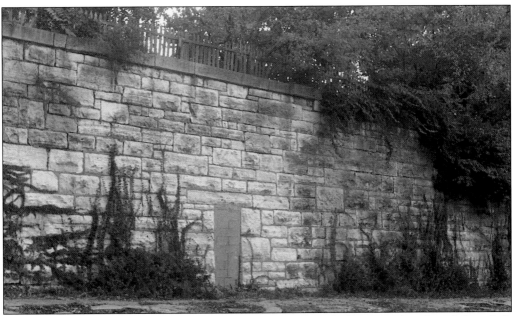

Shown here is the retaining wall built to separate the north end of Benton Place from Schneider's bar-restaurant. Hickory Street, which was extended below the wall, provided further distance from the bar.

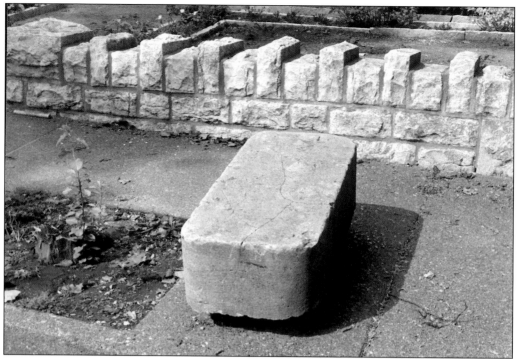

This concrete stepping stone was used by Victorian and Edwardian passengers to step down from their carriages.

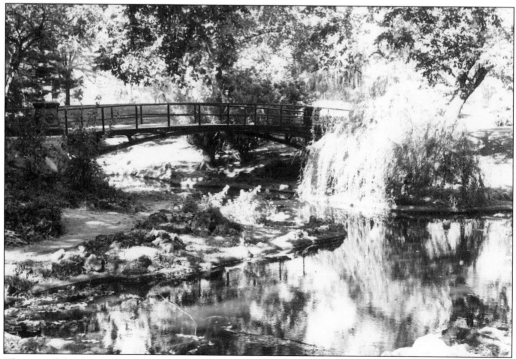

The small bridge over the lagoon in Lafayette Park was well secured by the engineering of its end supports.

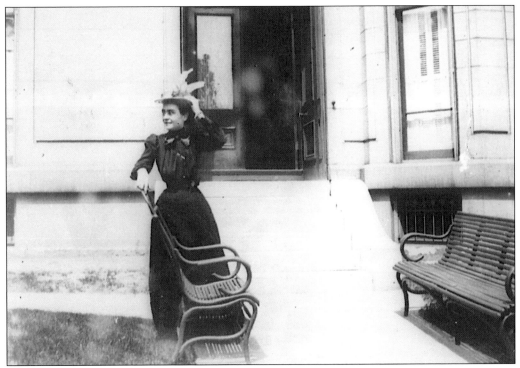

A Rainwater relative is shown on the steps of Benton Place as she prepares for an outing.

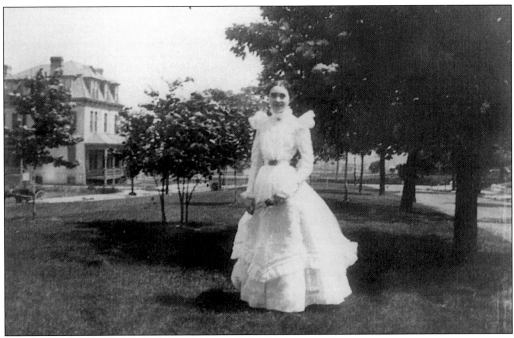

A young lady attends a picnic on the grounds of 21 Benton Place.

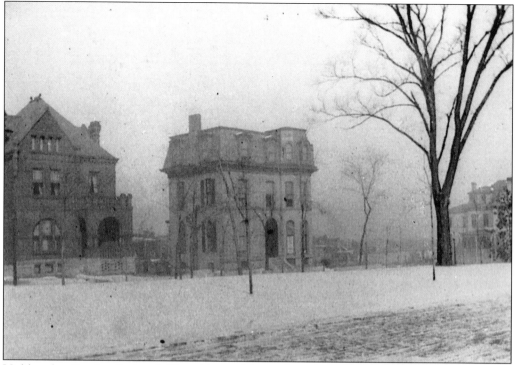

Unlike the Empire Style of 21, with its Mansard roof and high windows, next door at 15 Benton Place was an example of the Richardsonian Romanesque revival style.

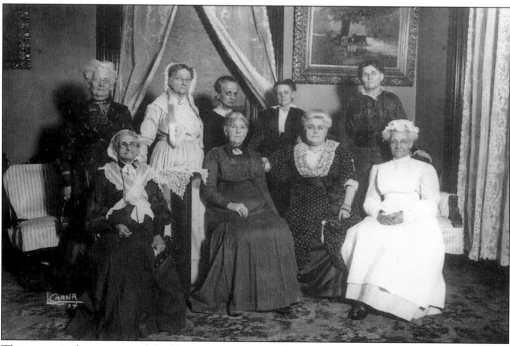

This portrait shows some of the Rainwater women relatives.

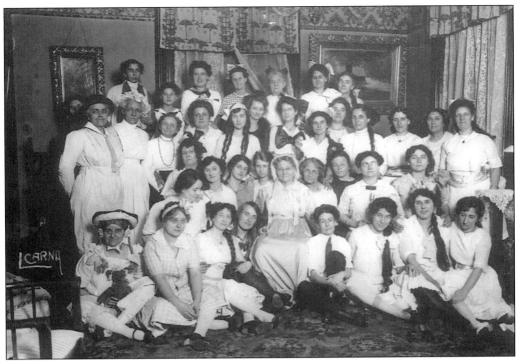

Shown here is a gathering of young ladies photographed in the Rainwater parlor.

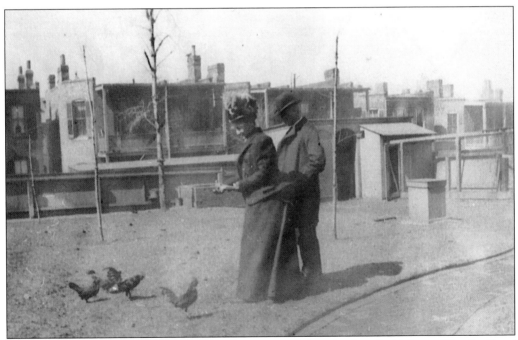

Mr. and Mrs. Rainwater are pictured feeding some of their backyard chickens. The family of that day often had fresh eggs from their own stock.

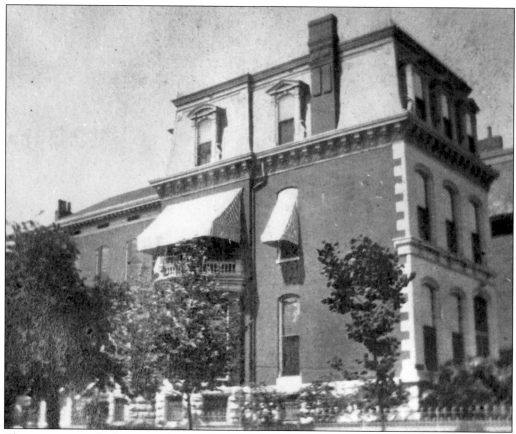

This structure at Lafayette and Waverly was one of the most outstanding in the area. It went through a devastating decline but was restored recently to some of its past grandeur.

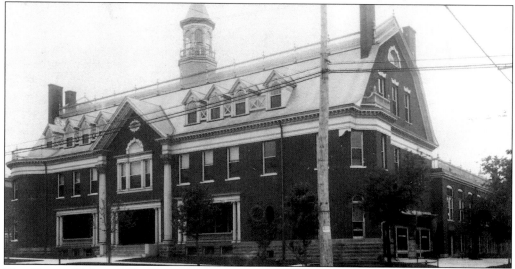

The Union Club at Jefferson and Lafayette was used as a gym for the affluent of Lafayette Square. It was destroyed in the 1896 cyclone and rebuilt as pictured; however, this building was torn down in 1955.

Four

DISASTER

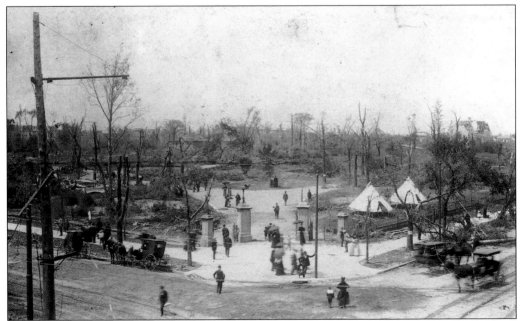

Depicted is the work of the organized aid after the destruction of Lafayette Park by the 1896 tornado. The storm had swept directly through the park creating complete destruction. Notice horse and buggy and army tents. This is the northeast entrance.

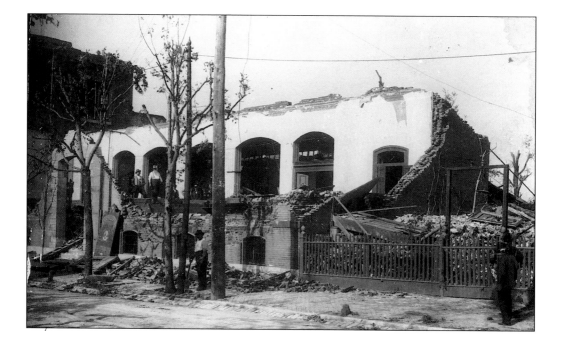

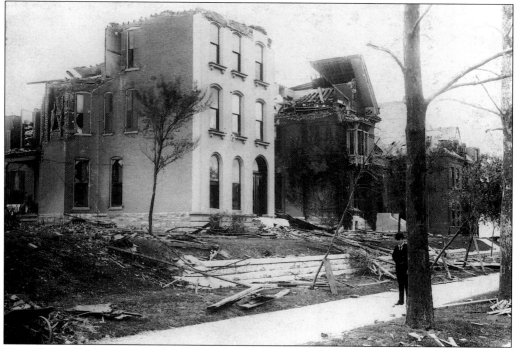

These houses had been ripped and torn apart by the ravishes of the tornado, which had cut a swath through Lafayette Square.

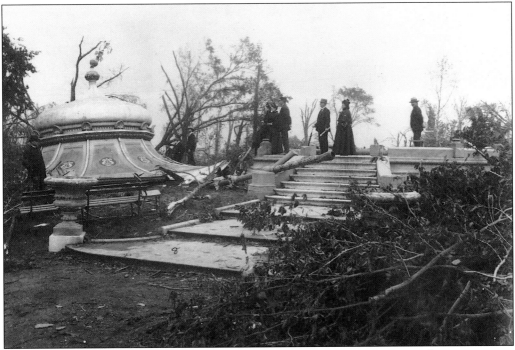

The band pavilion that was the site of Wednesday and Thursday concerts now lies in a massive rubble of wood and stone.

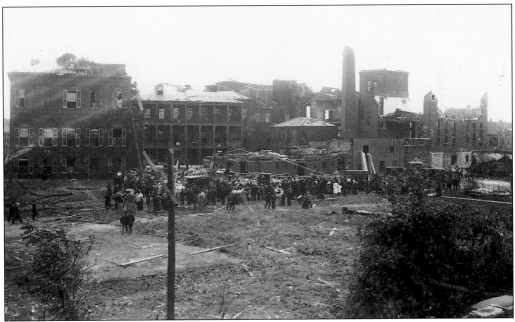

The storm, which had begun in the southwest corner of the city, had torn a path southward and hit Lafayette Square as well as two other neighborhoods nearby. Depicted here is still further evidence of its rage.

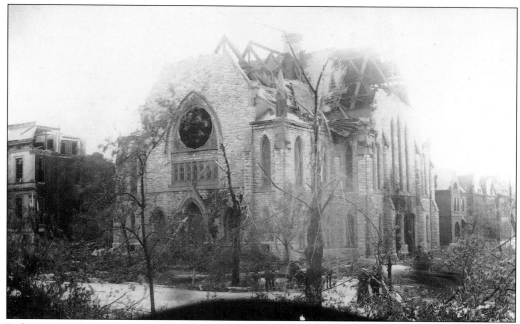

Lafayette Park Presbyterian Church is shown from the northeast corner after the destructive ravages of the tornado. The Rose window was badly damaged.

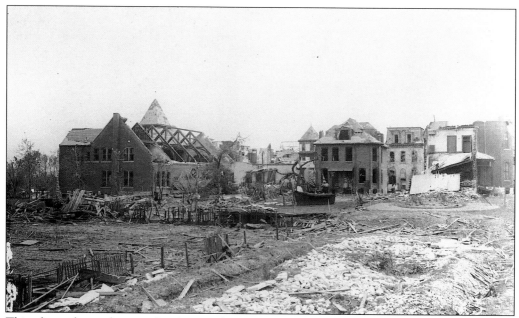

This photo shows the vast destruction that was provoked by the cyclone. Scattered trees and plants were tossed everywhere, and some pulverized.

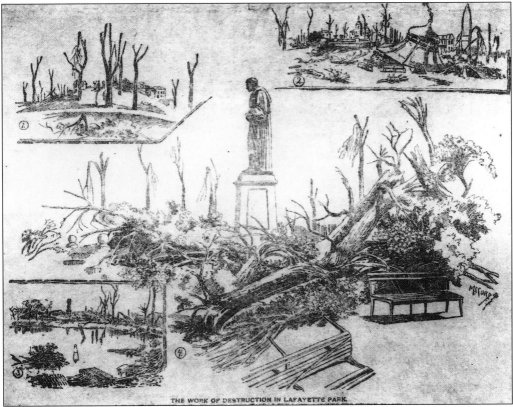

An illustration of the park's destruction details scene by scene the enormous damage suffered.

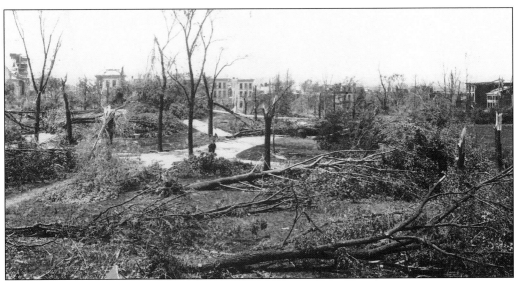

The storm's rage cut a path that led to the Mississippi, where it began to pound the water and bridges. Even parts of the masonry from the great Eads Bridge were hurled about.

This house escaped the storm entirely.

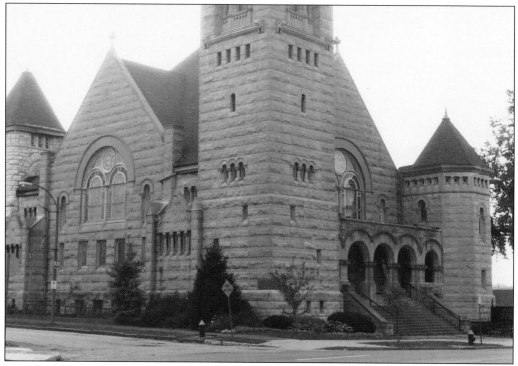

This church was badly damaged but repaired to its present state.

Five

DECLINE AND
DESTRUCTION

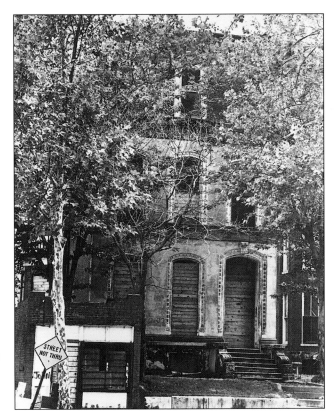

By the 1920s the neighborhood around Lafayette Park was in a neglected state. The desolation of the area is well illustrated by this house on Lafayette, which was once a fine mansion.

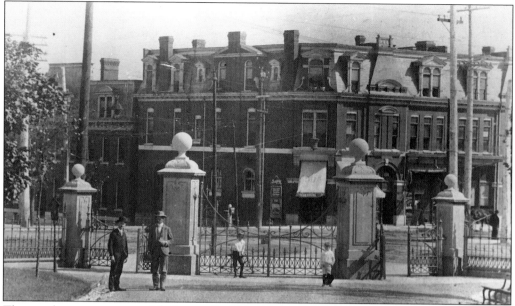

The northeastern corner of Lafayette Park during the period of the decaying neighborhood illustrates how many splendid dwellings became rooming houses for transient workers.

This historic building at Eighteenth and Chouteau, once the pride of the neighborhood, has undergone vast decay and destruction as shown. The need for rehabilitation has continued to the present day as this photograph so graphically illustrates.

Some residents stayed in the Square after the tornado; a Dr. Russell, who was a popular practitioner of the day, owned this house on Hickory.

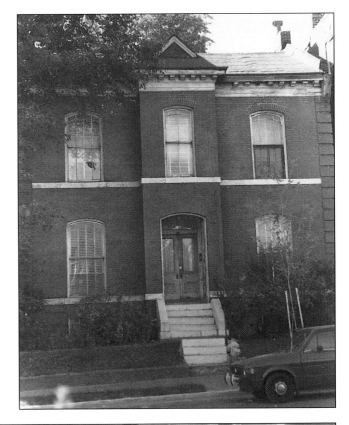

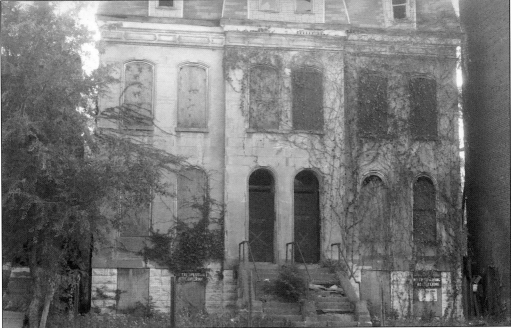

This row of houses on Chouteau Avenue, once owned by prominent figures such as James Eads, continues in the present state of disrepair. They await avid buyers to restore them.

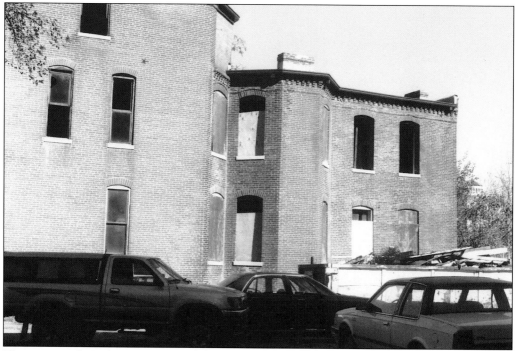

The rectory of a Dolman Street church is now being restored. Although its adjacent church was owned by several sects, it is only now that restoration has taken place. This is being done under the auspices of its new Catholic owners.

This area near the Northeast Quadrant of Lafayette Square is still undeveloped by any enterprising, resourceful buyer. These photos illustrate the fact that restoration is constantly needed in the Square.

Six

RENEWAL AND RESTORATION

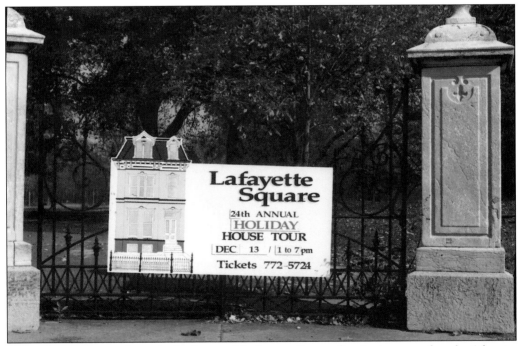

As we have often indicated, the heart of Lafayette Square lies in its central park. After its flowering in the nineteenth century, and its destruction in 1896, the park suffered a series of reversals. During its long decline, scant attention was paid to this greensward; however, as the restoration of the area began and continued, attempts have been made to better the Park whenever possible. Depicted here is a sign of the new times: an invitation to the Square's annual house tour.

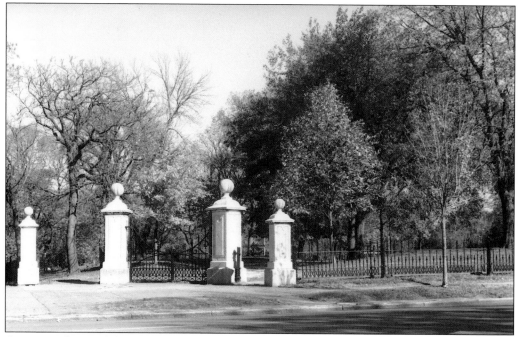

A recent photo of the northeastern entrance to the Park at Mississippi and Park shows the rounded tops of the stone pillars that connect the iron-caste fence. They once had gaslights attached to them; later they were replaced by electric lamps. These too are gone.

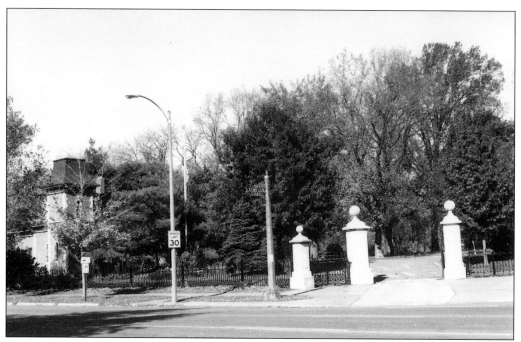

The southeastern gate-entrance to the Park at Mississippi and Lafayette is shown in a recent photo, as evidenced by the nearby police station.

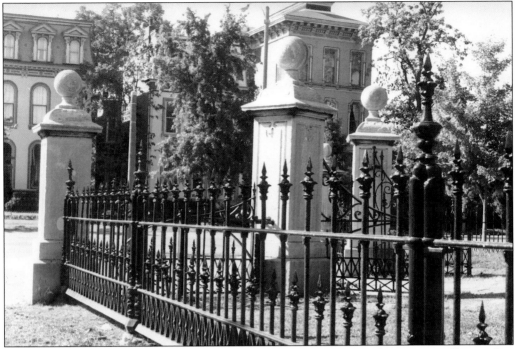

This elaborate fence, which has recently been repaired and repainted, was originally raised to replace an old wooden affair that wrapped around the grounds. Here we see the fence in its renewed smart state.

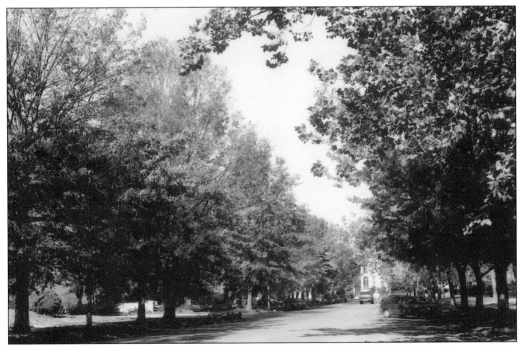

This row of pear trees in a rare symmetrical pattern lines both sides of Mississippi Avenue. The west sidewalk of the street directly faces the Park.

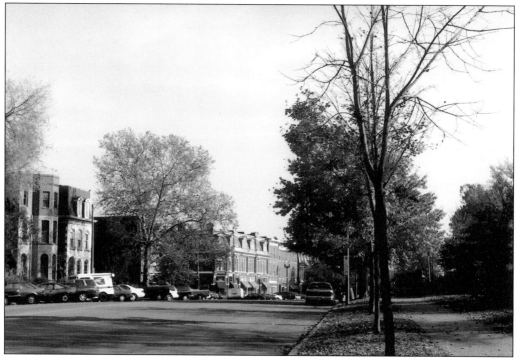

This is a wide view of Park Avenue with the sidewalk of the Park on the right, and the houses and stores that face the park's grounds on the left.

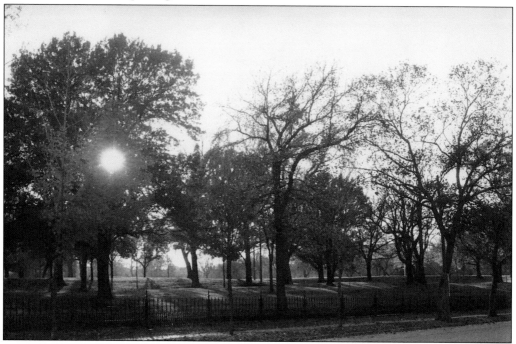

This view from the south side of the Park reveals the size and shape of some of the trees planted upon it. The Lafayette Park Garden Club, a group of spirited residents, has introduced new specimens of trees to add variety to the standing old ones.

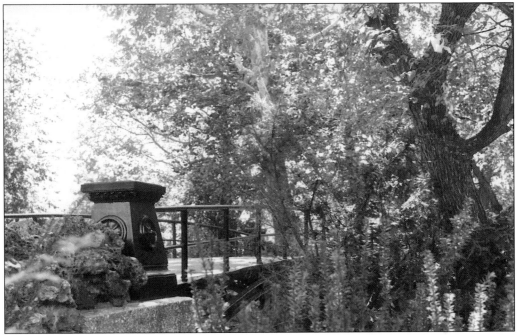

The Rockery Bridge and Grotto is one of the most attractive sections of the Park, a setting of sylvan bliss. Sought eagerly for meditation and reflection, this lagoon and its splendidly wrought bridge were patterned after a European model.

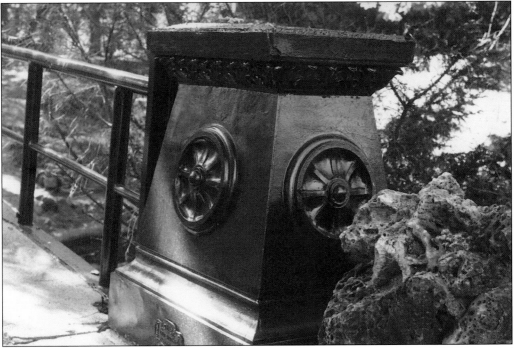

The majestic iron bridgework of the tiny "Tom Thumb" bridge has withstood the ravages of not only time but the 1896 tornado as well. Recently, attempts have been made by the Garden Club to renew some of the grotto aspects of this sanctuary.

This winding path through the northeastern gate is one of the eight gate entrances to the area. The trees on these grounds are frequently monitored as to their age and condition.

The famed Park fence was constructed in 1869. After a commissioned design, it was erected by a local firm, which had contracted to build a fence that was 5 feet 3 inches high. This fence was also erected to enclose the Park on all sides.

With the additional expense for the iron gates, the cost of erecting the fence grew to $50,000, a great sum in those days.

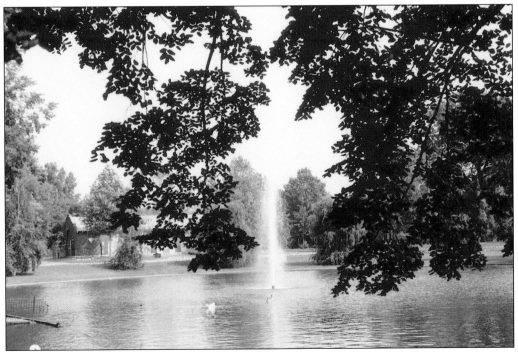

This is a view of the small lake in the middle of the grounds. The fountain has recently been installed and should be compared to the Victorian fountain shown earlier.

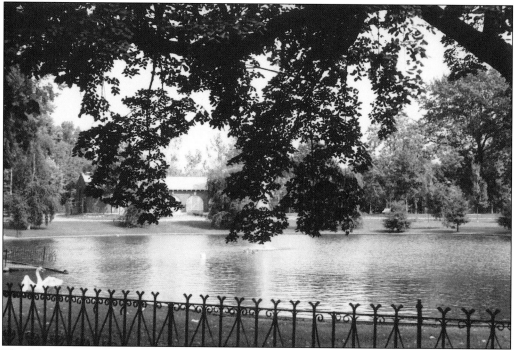

The lake, equipped with a swan, ducks, and geese, is also a place where many come to fish. Here we get a view of the lake from the southwestern bank, and in the distance we can see the boathouse.

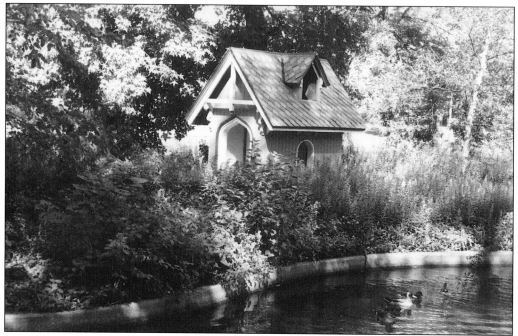

This is the new duck house built to replace the old-fashioned duck house as shown before. It sits in the same spot in the lake and was erected in the memory of Al Doede, who did so much for the renewed landscaping of the Park.

Shown here is a view of Park Avenue as it appears from some distance away in the Park.

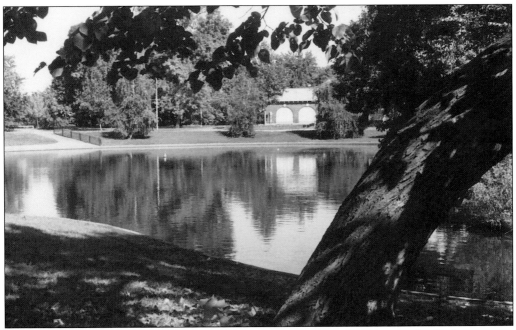

As this photo will attest, the trees and foliage surrounding the lake in the Park are quite arresting, particularly the one weeping willow who lords over the east bank.

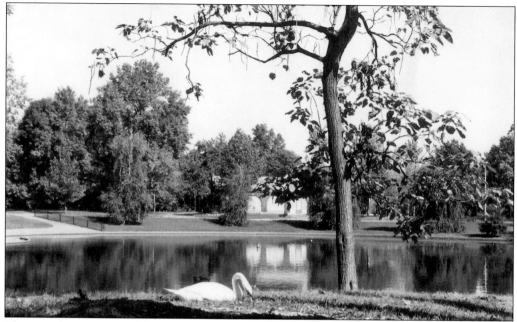

This is a photo in time-scale—a young tree standing on the shore of an old lake.

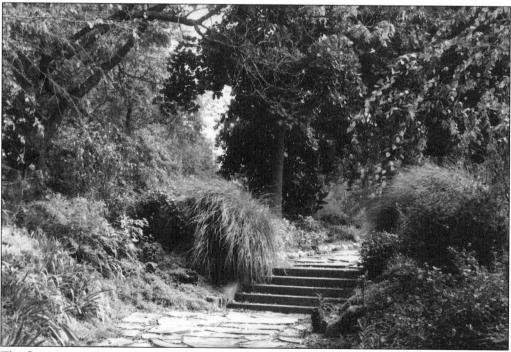

The flowery entrance to the Park's famed rock garden was in decline for many years until master gardener Ruth Kamphoefner and her horde of helpers recently resurrected it. This fine lady is in reality the most committed citizen in the Square.

Seven

STREETS

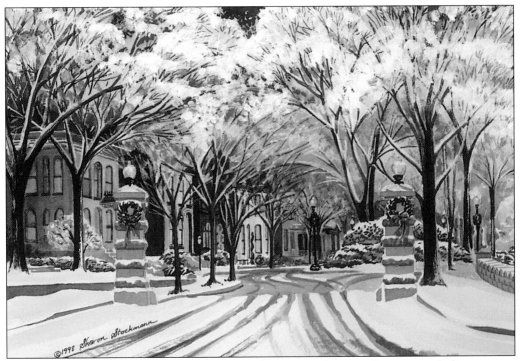

Benton Place is seen here as sketched by Sharon Stockman, whose annual drawings on Christmas cards illustrate the winter charm of Lafayette Square.

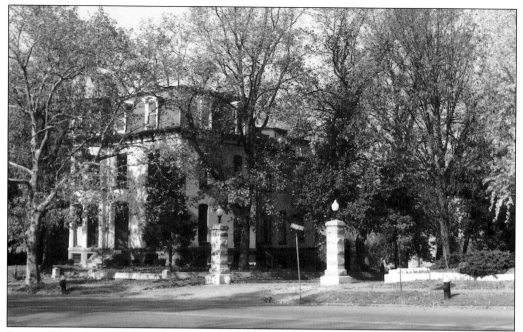

Benton Place, St. Louis' first designated Federal Historic District, is the oldest remaining private street in America. As we have noted, Montgomery Blair initiated it. In 1868 he commanded Julius Pitzman to lay out the second private street in the city. Pictured here is the southern pillared entrance to the division.

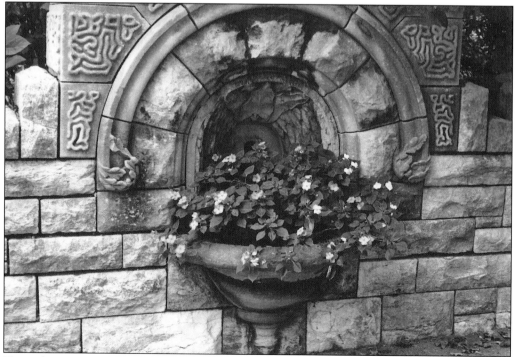

Near this entrance is a water trough for horses; it is now used as a decorative basin for growing flowers.

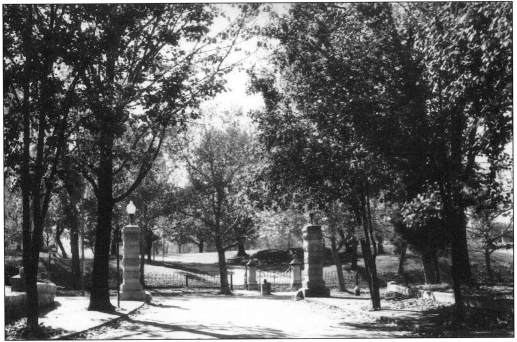

As we advance farther down the street, we see at once the avenue of trees that have been planted around the circular roadway of Benton Place.

Benton Place was designed as a cul de sac, with homes built across an elliptical park. It was designed as a private street to attract wealthy buyers.

Shown here is a view of the ornamental median that acts as a greensward in the middle of Benton Place. Some of the trees are very ancient indeed.

As one contemplates the silence and beauty of Benton Place, one can experience the power of this scene from this parkway.

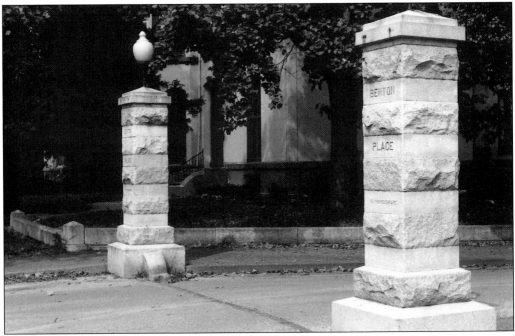

In 1973, the United States Congress placed Lafayette Square on the National Register of Historic Places. The scene pictured here may have influenced that decision.

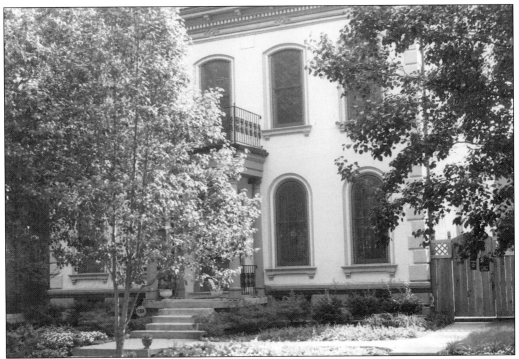

Although many a hardy restorationist has tackled 28 Benton Place to resurrect it from its shameful state in the 1960s, it has only been the present owners who have brought about its grace and finish.

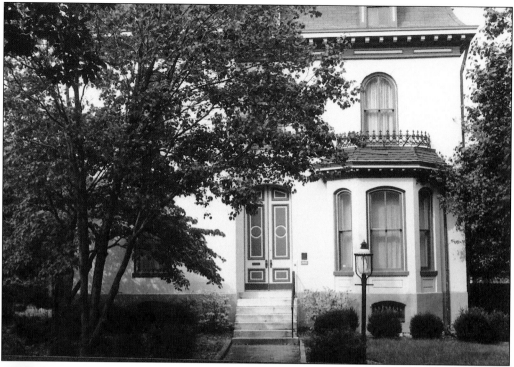

Five Benton Place was built in 1867 for Montgomery Blair. It was sold eventually to Cynthia Desloge, daughter of the local business magnate. She was noted as a legendary St. Louis socialite of the day.

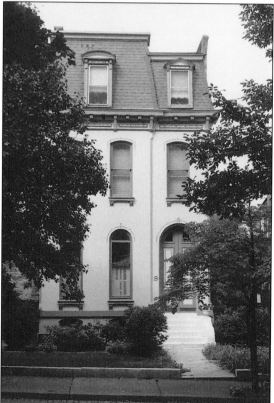

Nine Benton Place was renovated in the 1970s to a degree, and was fully restored by subsequent owners. Another example of the Second Empire Mansard roof dwelling, this house was extensively reshaped by its first owners in 1970. A kitchen was placed in the cellar and the stairwell refurbished. A later occupant erected a carriage house in the rear, which was handsomely built.

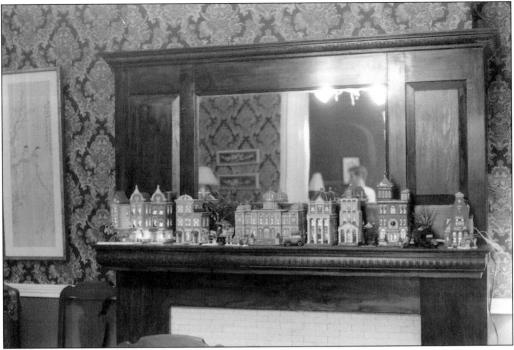

Each year Lafayette Square holds a Christmas tour, and on these occasions various houses are opened to the public. Depicted here is a mantel holiday display at 30 Benton Place, the home of Matt Brazelton and Jeff Jensen.

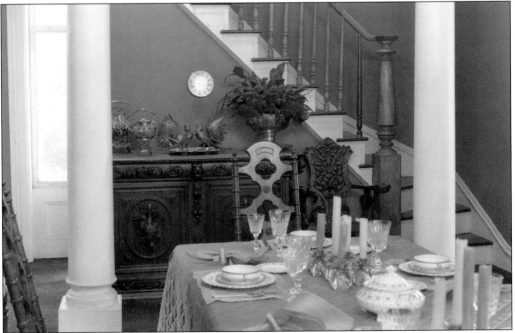

This gracious house now owned by Pat and Terry Barber was once the home of a circuit judge and his wife. As can easily be judged by the photo, 34 Benton Place, in all of its restored dignity, has a lovely dining room with an appropriate table setting.

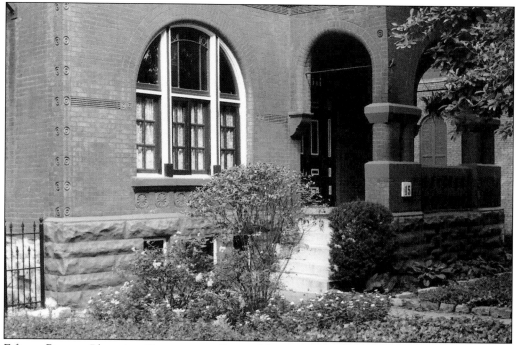

Fifteen Benton Place is a Romanesque Revival home with a long history of various owners. Once a boardinghouse, it finally came into its own under the care of its present owners and their predecessors, both of whom helped to restore it to its present state.

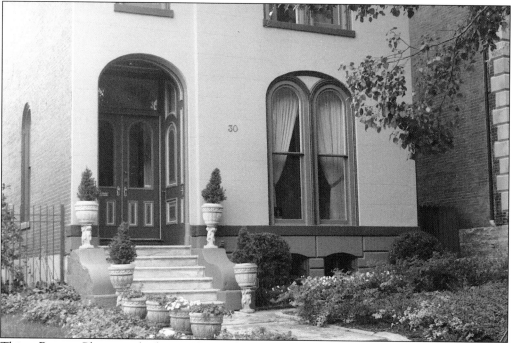

Thirty Benton Place was built in 1872. Colonel Edward S. Rowse lived there for many years and made his business career in real estate and insurance. The present owners of the house have been most devoted in restoring the house to its original state.

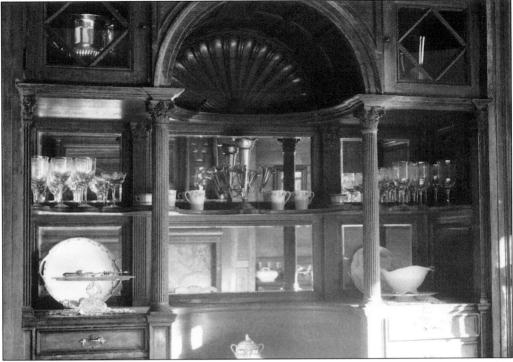

One of the grandest houses on the Square is 10 Benton Place. It was built in 1867 and sold in 1899 to Frederick Lehmanm, who later became solicitor general under President Taft. Pictured here is the sideboard built into a wooden-paneled dining room.

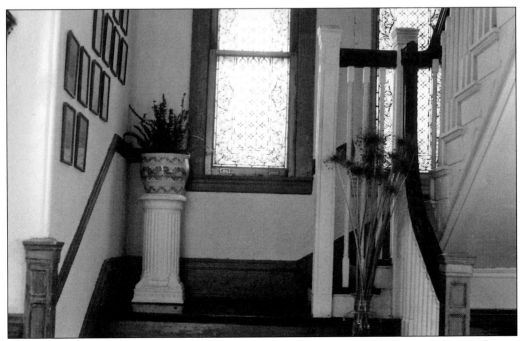

The elaborate stairwell and landing of 10 Benton Place is shown here with its stained-glass windows.

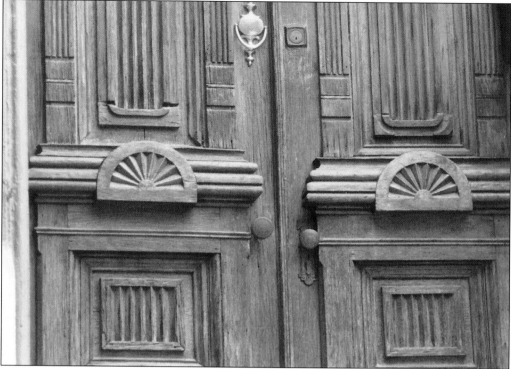

The finely carved doors of 22 Benton Place are shown here. This was once the home of a family whose son was killed in the Spanish-American War, and President Roosevelt came to this home for his funeral.

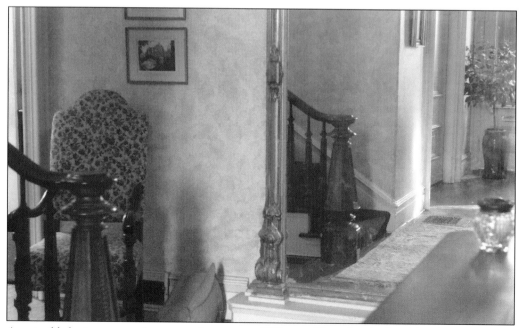

A vast gilded mirror greets the guests who come to 10 Benton Place for a bed-and-breakfast weekend.

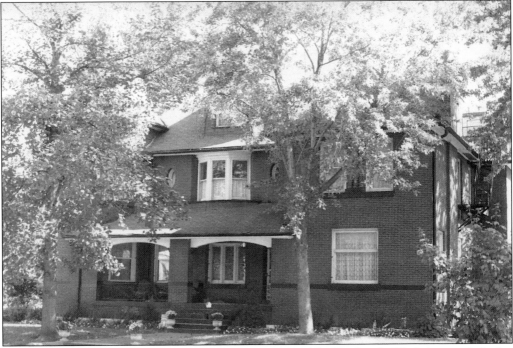

Ten Benton Place is a 19-room residence once owned by Frederick W. Lehman. It had a Japanese boy manservant and pet chickens.

Here is a collection of bird houses at 38 Benton Place, an aviary of sorts, which the owner, Don Little, has erected so that he might listen to the pleasant sounds of as many birds as possible.

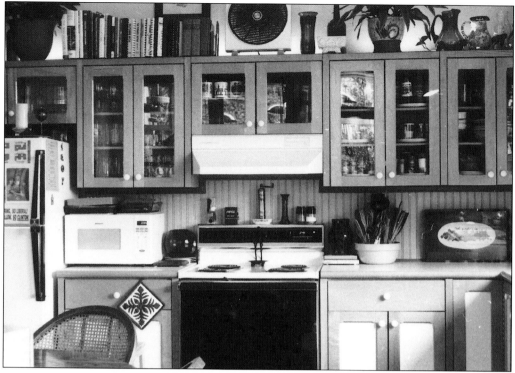

Depicted here is the modern kitchen of 38 Benton Place, which in some ways retains its old-fashioned flavor.

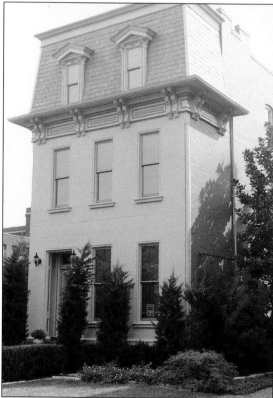

Thirty-Eight Benton Place, built at the end of the street curve, is one of the modern homes designed to resemble as closely as possible the ancient homes of the Square.

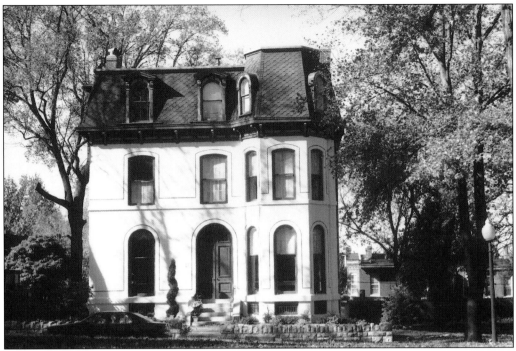

Owned by Elaine and Jim Barry, this house has not only recaptured some of the elegance and grace of the Rainwater period but has surpassed it. Twenty-One Benton Place is often considered the most opulent and graceful structure in the Square.

Shown here is part of the landscaping at 21 Benton Place. There has been the introduction of two window flowerbeds and of a creeping vine that will eventually engulf part of the house's wall.

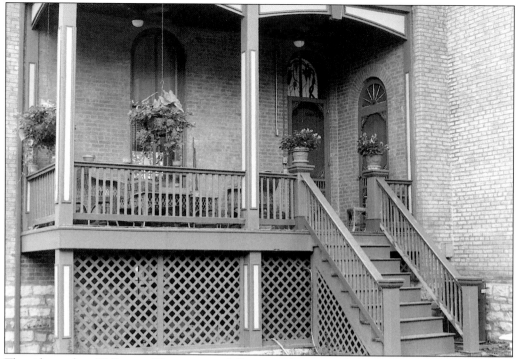

The side porch at 21 Benton Place was carefully restored to resemble the original Rainwater edifice.

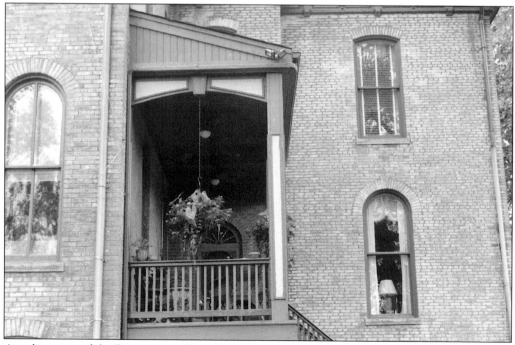

Another view of the Rainwater side porch at 21 Benton Place is depicted here.

A topiary fur tree recently placed in front of 21 Benton Place is surrounded by variously hued plants.

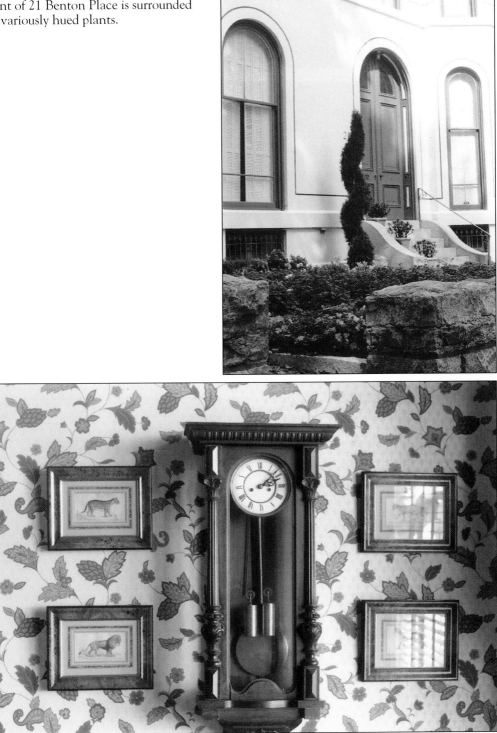

The parlor of the home is shown with its ornate antique clock.

Various pieces of Victoriana are shown in this photo of the parlor of 21 Benton Place.

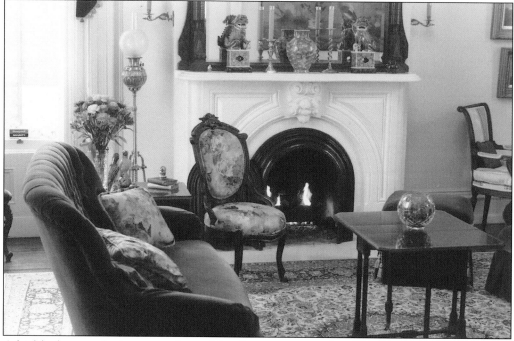

A highly decorated mirror, mantle, and fireplace are seen in this view of the parlor.

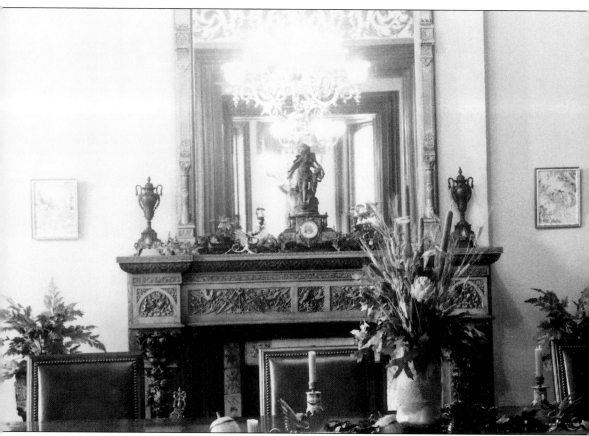

This lovely fireplace, inside the former home of Montgomery Blair at 2043 Park, somehow managed to survive and now stands as a testament to its "rehabbers."

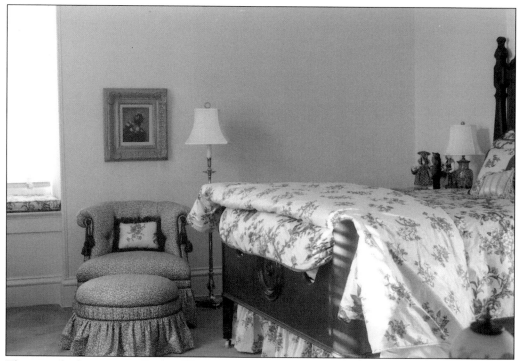

The guest bedroom at 21 Benton Place is seen here with its paneled window seats.

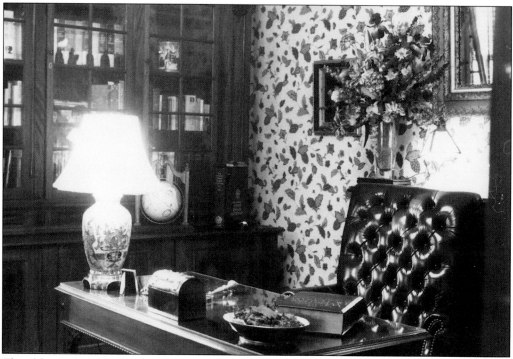

The library at 21 Benton Place with its huge bookcases and antique leather chair is quite impressive.

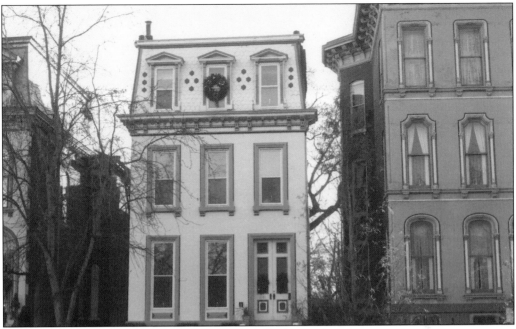

A quietly dignified structure, 2012 Lafayette (center) was erected on the estate of David Nicholson in March of 1878. It was sold to iron magnate William Simpson, who later moved down the street where he created Simpson Place. This mansard-roofed town house managed somehow to survive the 1896 tornado, although a hundred feet across the street Lafayette Park was pulverized.

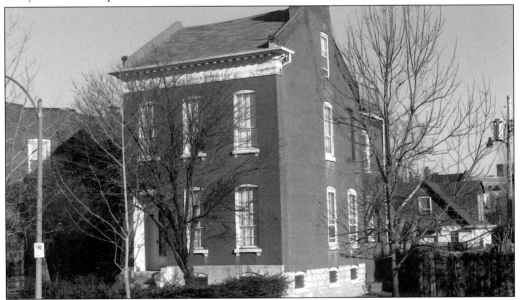

This Federal-style town house at 1440 South Eighteenth Street was erected around 1875. Its roof, which was greatly damaged during the tornado, was repaired with a makeshift affair, which lasted until 1975. At that time a new owner replaced the entire roof. The house, despite the wear and tear it experienced, has finally regained much of its former elegance, thanks to the efforts of its owners.

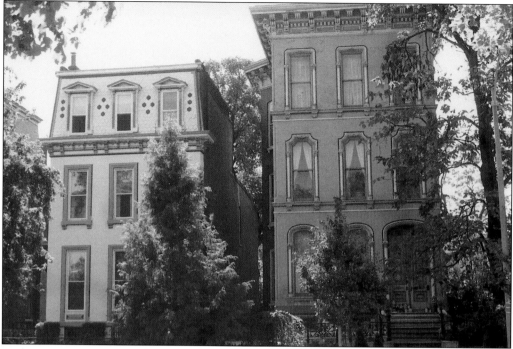

By far one of the great houses of the Square, 2018 Lafayette (right) is a grand imposing structure with ornamental windows and massive doors. With its sandstone facade it looms over the area with an authority and presence unequaled by any other residence.

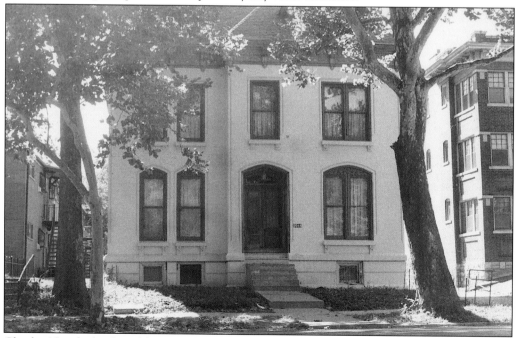

Charles Nagel, the famed lawyer who later became Taft's Secretary of Commerce and Labor, resided here at 2044 Lafayette. Louis Brandeis, who became the noted Supreme Court Justice, also lived here.

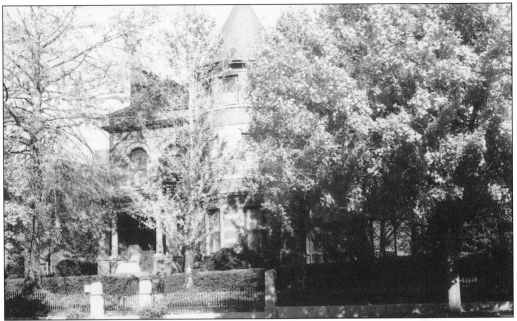

The second owner of this mansion at 2315 Lafayette, Dr. George Seib, a medical doctor, was able to keep it in splendid shape through the declining years of the Square. He also maintained a garden, formally landscaped by a professional gardener, that even today delights the eye with its arrangement and beauty.

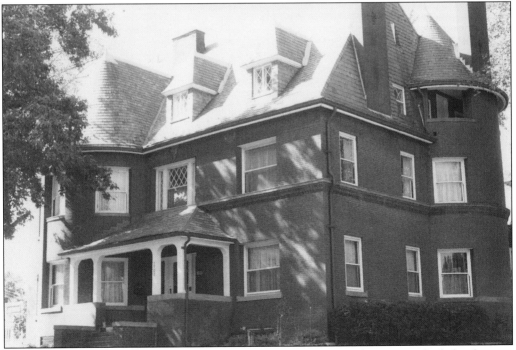

A Romanesque revival structure with castle-like towers, 2126 Lafayette was built by the iron works tycoon, William Simpson. He also built for his brother-in-law, J. Christopher, a similar house across the road called Simpson Place.

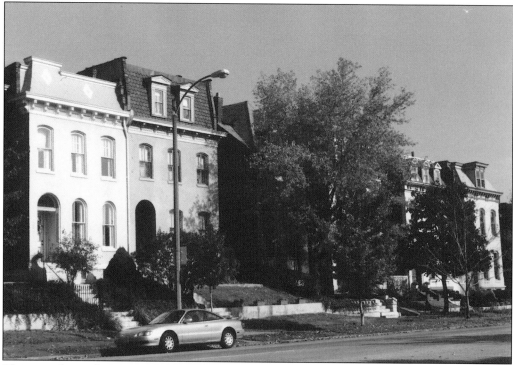

This row of town houses sits on an embankment overlooking Lafayette. From this position, they watch with a guarded eye the affairs that occur upon their street. There is a slight air of mystery about them as they survive from year to year.

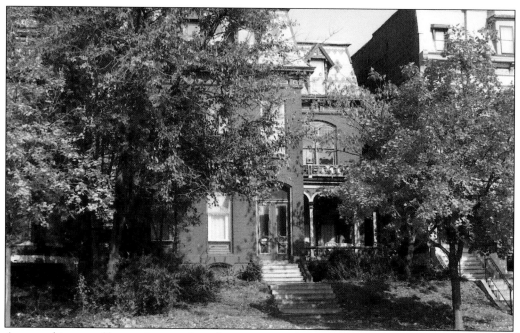

Among this row of houses is one of startling graciousness. Its grace is enhanced by a side porch, gazebo-like in structure, that hugs the house with affection.

Pictured here is 1718 Simpson, the long time home of the late Hal Frazer, the grandson of William Simpson. A warm friend and kind neighbor, Hal was the last surviving member of the Simpson clan.

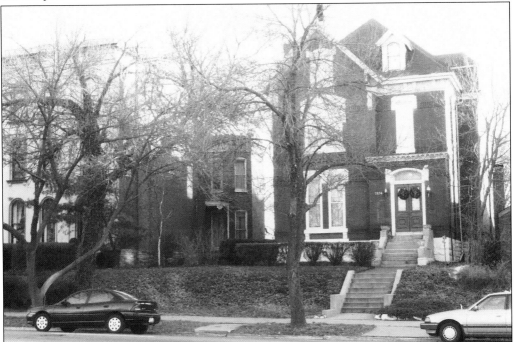

Famed bridge builder James Eads gave as gifts to his daughters the house at 2156 Lafayette and its next-door neighbor. His funeral also took place in this house.

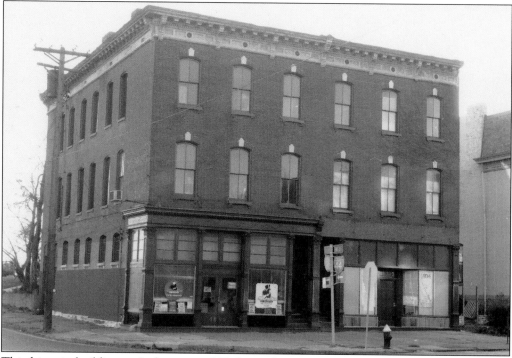

This historic building at Lafayette and Eighteenth Streets, laid out in a series of shops and offices, has certainly had its share of tenants. It has been everything from a drugstore to a doctor's office, a ballet school to a dime store, and a dog salon, among other things.

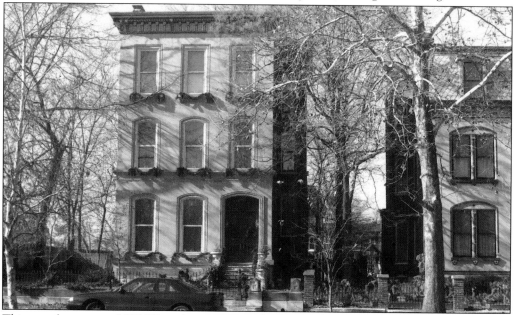

This grand structure, 1723 Waverley, was once the home of the famed jeweler D.G. Jaccard. It barely escaped destruction when a highway was cut through directly behind it; unfortunately, its once extensive garden did not escape. The building now stands in excellent shape as its owners, Tim and Theresa Becker, have faithfully restored it to some of its past elegance.

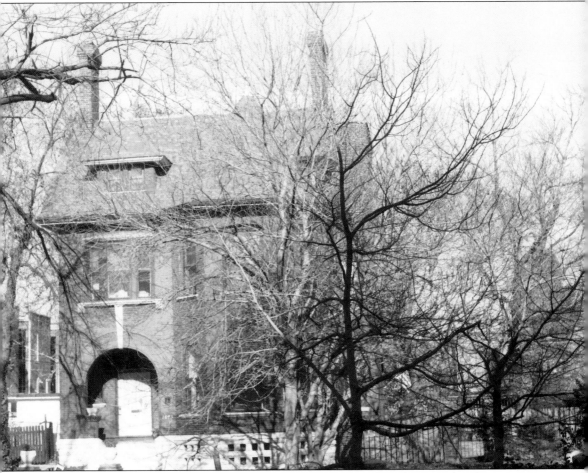

One of the most notable houses in the area, 1843 Kennett Place boasts a lovely staircase, stained-glass windows, and an expansive garden.

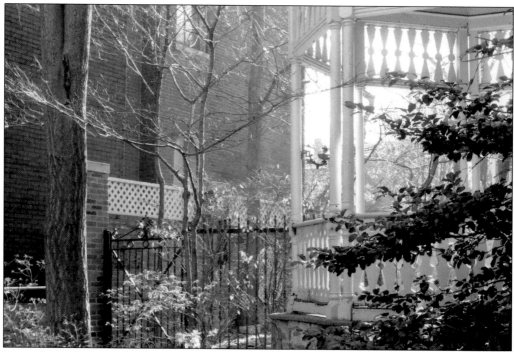

Erected in 1870, 1838 Kennett was at one time owned by Adolphus Busch. Although it went into a long decline—it was once a rooming house inhabited by dozens of people—it managed to survive until its present owners restored it to its now elegant state. Contributing to the beauty of the house is the gazebo pictured above, one of the few remaining in the Square.

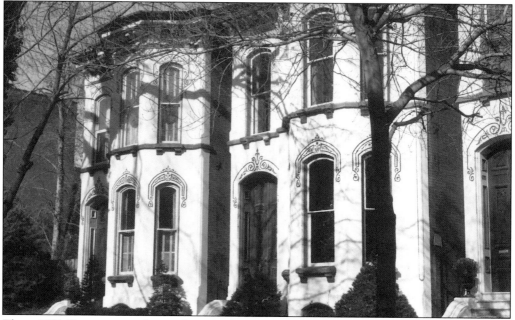

These 1831 Kennett town houses have undergone years of painstaking restoration. The middle house, 1831 Kennett, is owned by Suzanne Sessions, a leading designer of theme parks and an avid and tireless supporter of the Square.

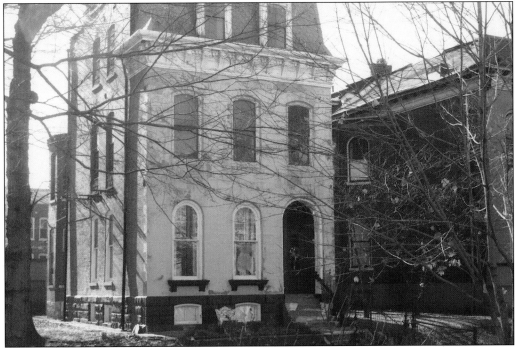

The years have brought many changes for 1824 Kennett Place. Built in 1879, its first inhabitants were all stricken by cholera and died. Fortunately, the house managed to survive the destruction of the 1896 cyclone, but it did so under the most primitive of circumstances. It is now being carefully restored by its present owner, Jeffrey Aytes.

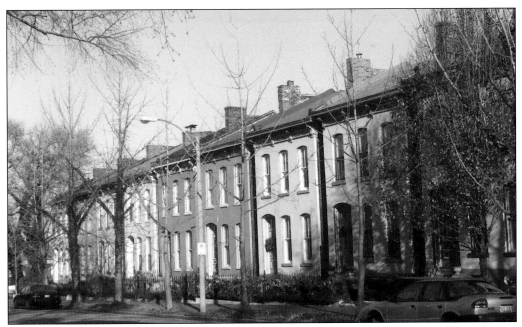

These Harris Row houses on Eighteenth Street were built with adjoining walls and were constructed in the late nineteenth century. All have been fully restored.

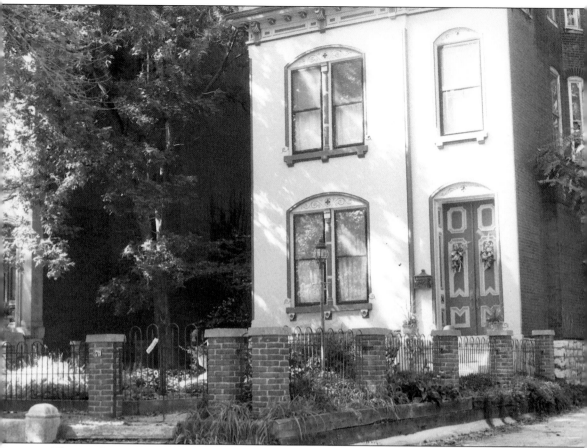

This residence at 1719 Waverley, next to the Jaccard home, has undergone extensive care and restoration. The brick enclosure of its front yard illustrates some of the innovations that the house has enjoyed under its recent owners.

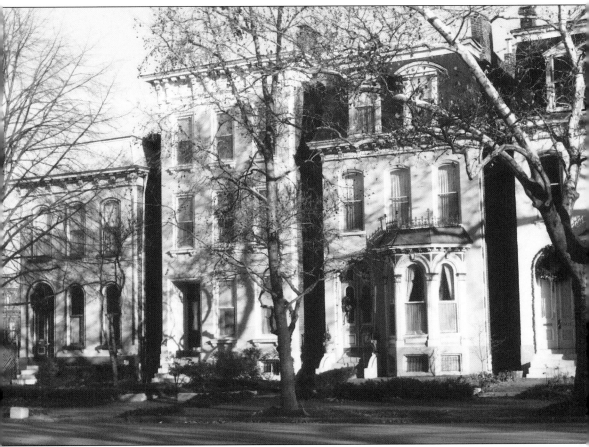

The prize real estate in the 1840s in the Square was that which stood around the Park. Architecturally these antebellum homes reflected the building tastes of the day. The free-standing town houses at 1418 through 1424 Mississippi were some of the earliest to be built in the Square, and were all lit with gaslights until the advent of electricity.

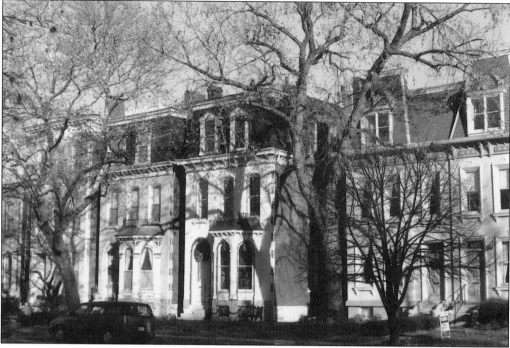

These houses (third and fourth from the left) from the same row depict the one-story bay, a feature very popular during the pre-Civil War days.

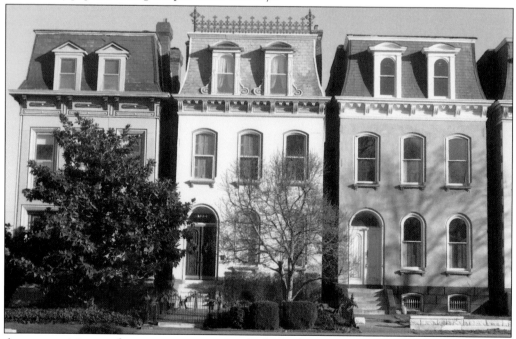

An enterprising real estate owner erected these free-standing similar town houses at 1534 through 1540 Mississippi around 1878. Note the cast-iron cornice and brackets topping the middle house at 1534. The current owner of this home has done much to add to its now excellent condition.

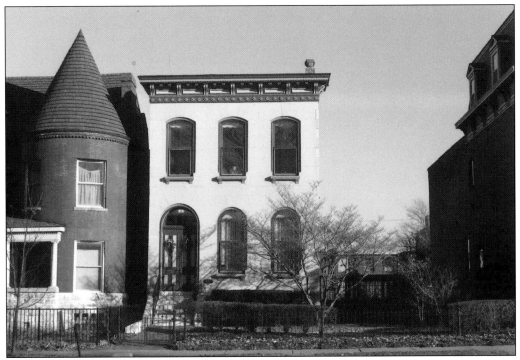

The 1526 Mississippi town house suffered the loss of its third floor during the ravages of the 1896 tornado. It was the home of a doctor, Edward Sanders, who was the first pediatrician in the city.

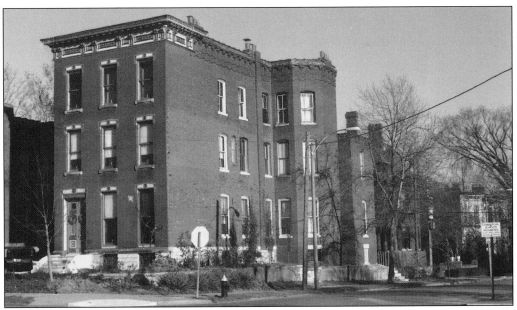

The tallest single house in the Square, 1554 Mississippi was greatly damaged during the tornado but was repaired soon afterwards. Built in 1896, it was the home of Dr. William Taussig, a business partner of the famed bridge builder, James Eads.

This array of flowers and other foliage decorating the front yards of houses on a side street demonstrates how willing the citizens of this enclave are to beautify this area.

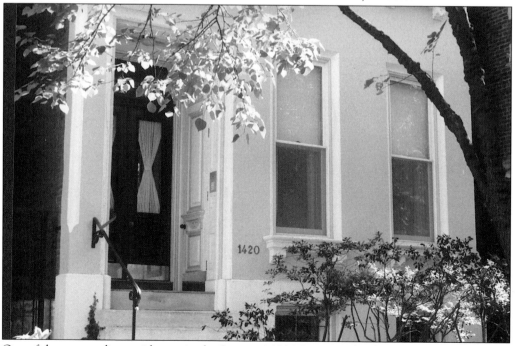

One of the outstanding residences in the Square, 1420 Mississippi has been carefully restored by its present owner, John Dwyer. Installing an elevator, creating a layer of new apartments, and filling the house with artfully placed objects, this owner has created a masterful residence.

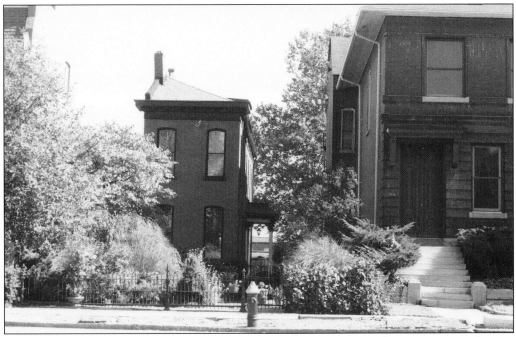

A curiously built house, 1512 Mississippi is one of the favorite sites in the Square. It was known as a flounder house, because it seemed to resemble a fish; however, it was erected to avoid paying full taxes. It was considered legally a half-house, hence half taxes. It was bought, repaired, and restored by the late William Redburn. Redburn's skill as a landscape artist is well demonstrated in the garden he created on the grounds of this house.

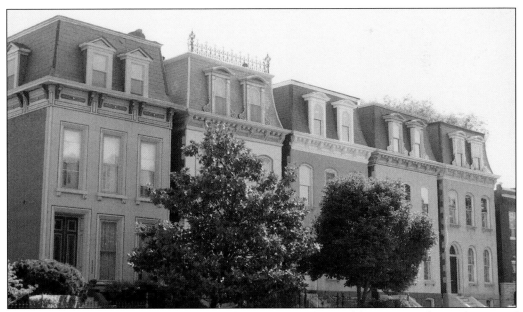

Another view of the late row houses on Mississippi is depicted here. Note the uniformity of these houses; all stand in a posture that is almost military in its precision.

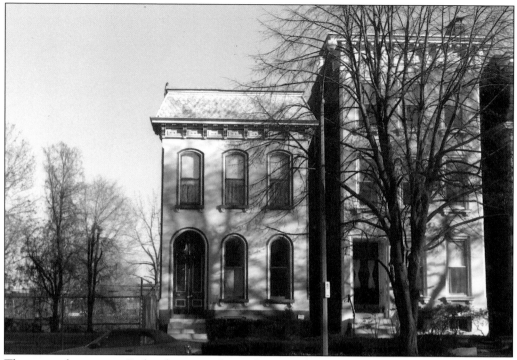

These two houses on Park take upon the ambience of a painting as the sun, shadows, and trees all commingle in the glow of full noon. Beside 1410 is a vacant lot, once the site of a popular neighbor bar. Beside it on the southeast corner of Park and Mississippi stands a newly constructed small park, where visitors can enjoy a leisurely day.

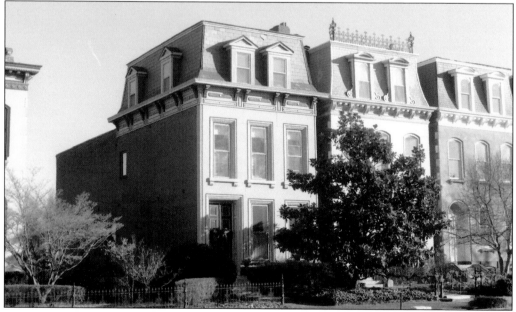

Horace Bixby, famed riverboat captain and instructor of Mark Twain in river lore, owned this home at 1532 Mississippi. He also figures greatly in Twain's account of this apprenticeship in his *Life on the Mississippi*.

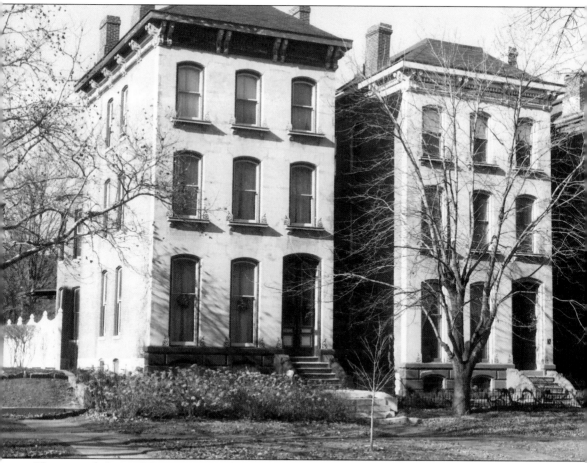

This row of elegant Victorian town houses at 1623 through 1616 Missouri illustrates exteriors that have changed little through the last hundred years. Built on the west side of the park, their interiors unfortunately suffered great damage during the vast decline. There were certain features that the new owners were able to save and restore, such as marble mantels and tin ceilings.

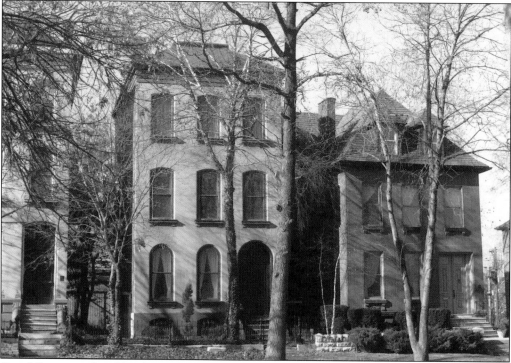

Carefully restored and landscaped, 1604 Missouri (far right) is by far one of the most attractive houses on the street.

Pictured here is the Tobin-Carlin home at 1435 Missouri. It was here that the 102-year-old Tommy Carlin, recently deceased, was born and raised. As the oldest living citizen of the Square, "Tommy," as she was called, was often asked to tell what life was like in the Square when she was a young lady.

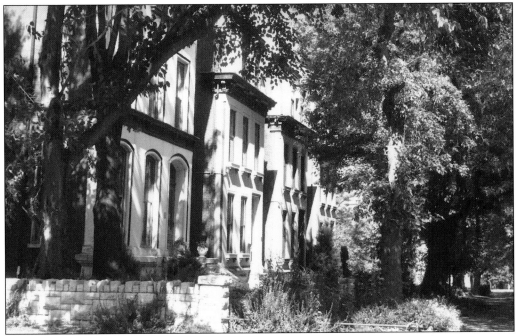

A long shot of Missouri Avenue, between Albion and Park Avenues, shows the avenue bathed in the fall sun as it prepares for autumn weather and winter snow.

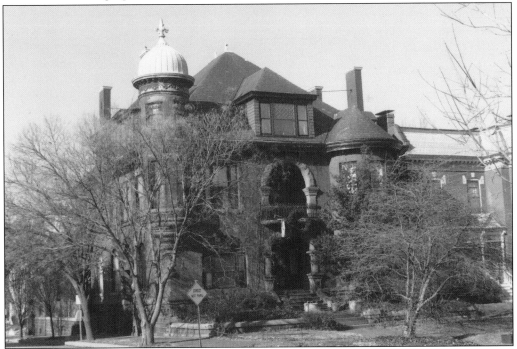

A striking building with its castle-like exterior, 1525 Missouri is one of the most opulent in the Square. It is in the Romanesque revival style, with a Queen Anne tower from which one could observe the whole area. A 27-room residence, it has enjoyed considerable interior restoration by its present owners.

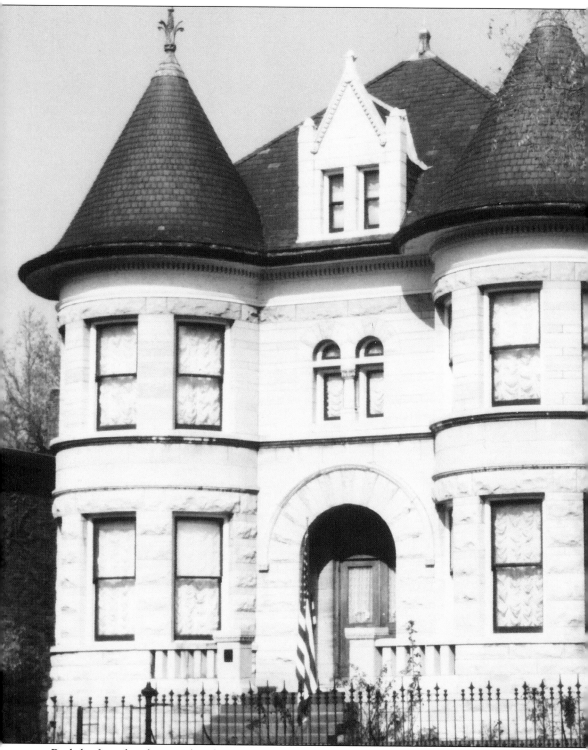

Built by famed architect Theodore C. Link, 2031 Park is a grey-stone mansion that has played a

great role in the history of the Square.

If other buildings are claimed to be the tallest in the Square, 2051 Park is surely claimed to be the largest. Presently it has been cut up into several large condominiums. It was once a school of some importance in the Square, and some talk of a suicide, a shooting into the mouth of one of its inhabitants, may or may not have occurred there.

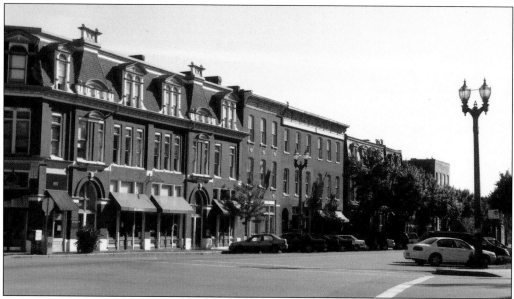

This row of shops and stores makes up the business district of the Square. These facilities, which first appeared in the late nineteenth century, declined to such a degree that some were uninhabitable. With the coming of the "New Square," restoration took place to such a degree that this group of stores has become quite chic and fashionable.

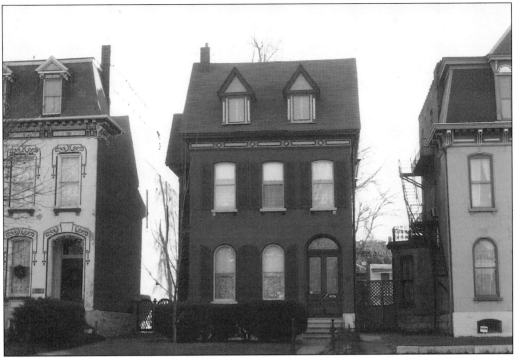

Pictured here is 2338 Park, the home of local artist Sharon Stockman, whose annual drawings of Lafayette Square scenes have become a Christmas tradition in the Square. Sharon and her husband Bill have worked hard over the years to bring this residence to its current excellent state.

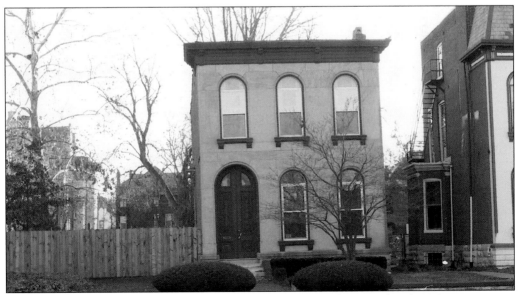

This residence may have suffered the loss of its third floor in the tornado of 1896.

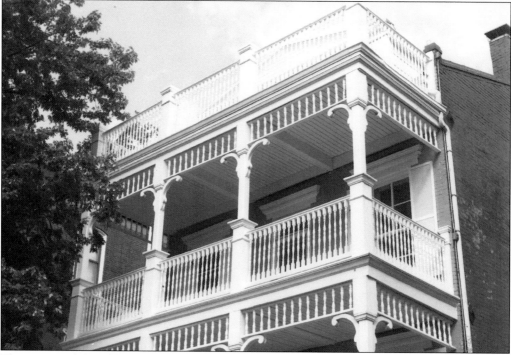

This is one of the oldest houses facing the Park from the north. It was built in the Federalist style that was so popular in the mid-nineteenth century. It has been brilliantly restored by its present owners.

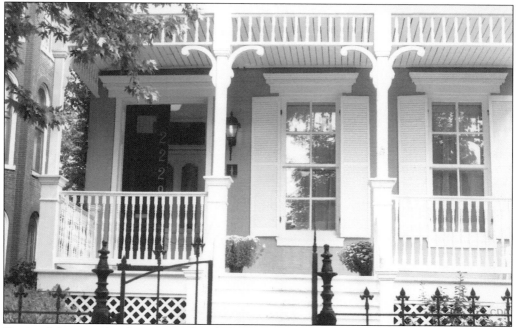

Depicted here is the front veranda of the Federal house. The house is generally painted white and takes upon the hue and color of a Southern mansion, despite being without the Doric columns.

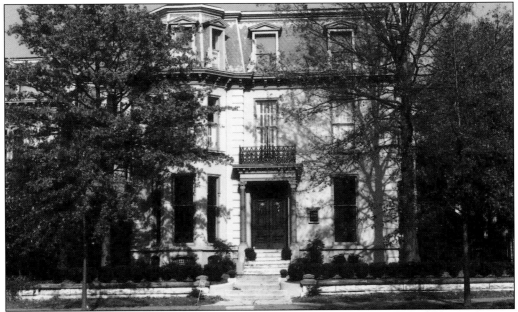

Once the home of the prestigious Montgomery Blair, this structure at 2043 Park was designed by George I. Barnett, a famed architect of the period.

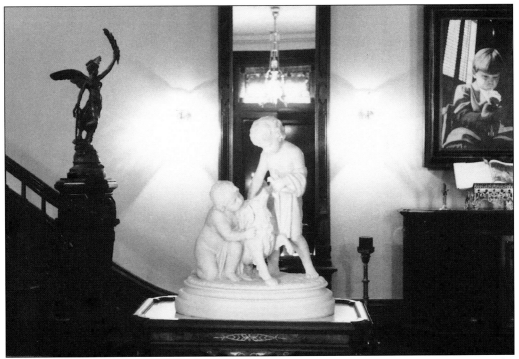

The elaborate settings in 2043 Park have been carefully arranged by the present owners, Mike and Carolyn McAvoy.

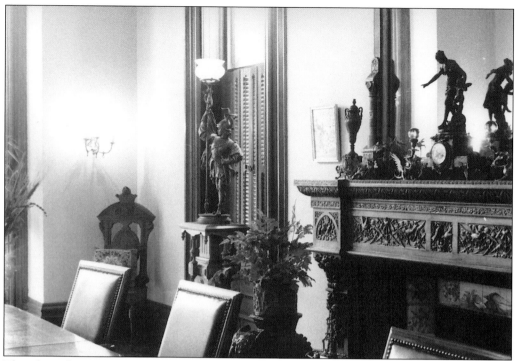

This photo depicts a parlor mantle with its carefully selected *objets d'art* in the Blair-Huse home.

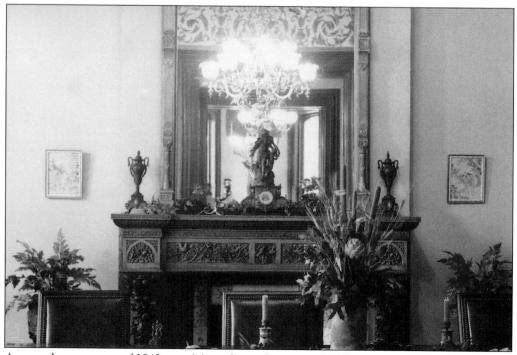

Among the occupants of 2043 were Mayor James Britton and William Huse, noted businessman.

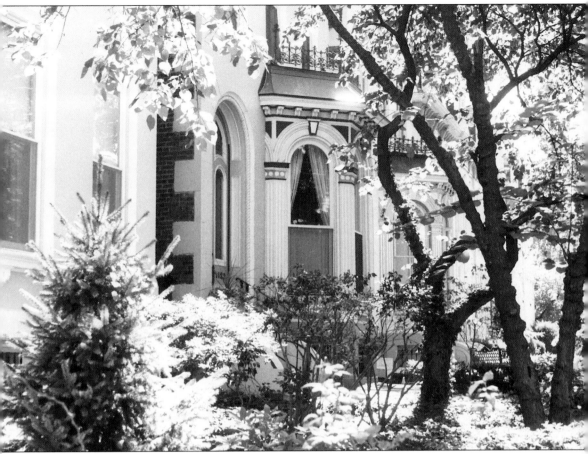

Here is a glimpse of spring in Lafayette Square with dogwood and wisteria to be seen everywhere.

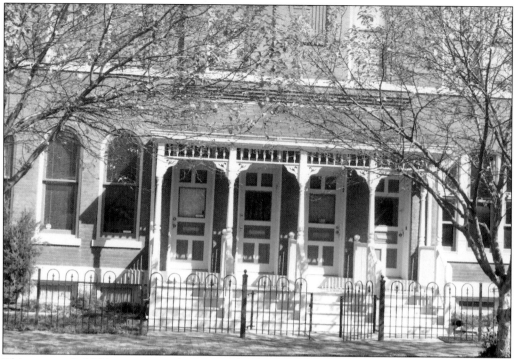

This group of old Victorian row houses is also located on lower Hickory. One is drawn to the ornate detail designed on the front wooden porches of this row of houses, an elaboration that is repeated from door to door.

This Missouri Street residence was purchased by Dr. Clarence Miller, a professor at one of the town's colleges, when it was already greatly renovated. He further achieved admirable landscaped front and back yards.

This sunburst design appeared on each of the Victorian row houses described on Hickory.

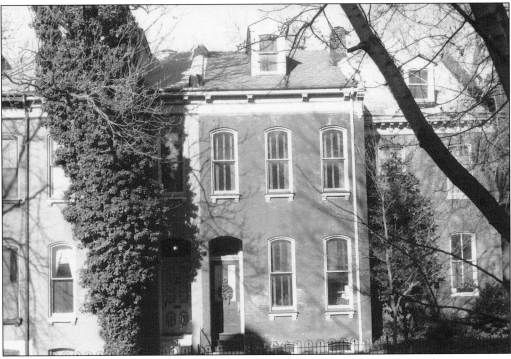

The town house residence of Herta Milhouse stands at 1913 LaSalle. It is of some interest because one sidewall of this structure is shared with a sister house, but on the other side it stands free and faces the front yard of 1911.

Lafayette stalwart Teresa Johnson, a longtime champion of the area, resides at 1911 LaSalle. The home was built somewhat differently from other houses on the street in that its side porch is really its front porch, a feature that characterizes few houses in the Square.

At first glance, the middle row house of this segment of houses appears to be as small as its front entrance. In fact these row houses are incredibly large, their space going up flight after flight of stairs. At the top of these stairs, Mike Stanton, the new owner of 1913 Hickory, has established a solarium of sorts to catch the roof-top sun.

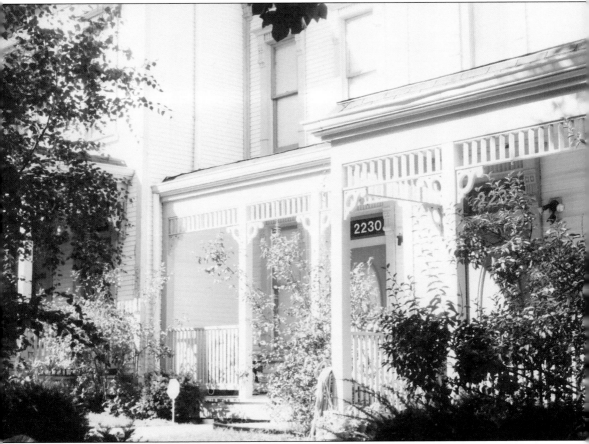

An area recently developed in the Square was one that included a cluster of houses with a central courtyard. Called the "Eclipse" because of its shape, this group of town houses was created to resemble Victorian or Edwardian houses as close as costs would allow. Here is a view of Hickory Street that cuts past Benton Place.

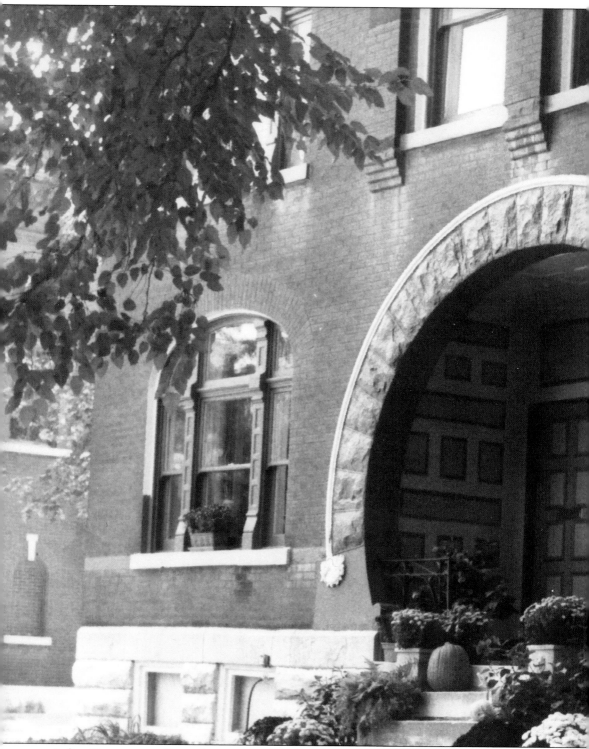

A fine Romanesque Revival structure, 1800 Rutger at the corner of Eighteenth and Rutger is by any measure one of the Square's most spectacular residences. Newly decorated by its

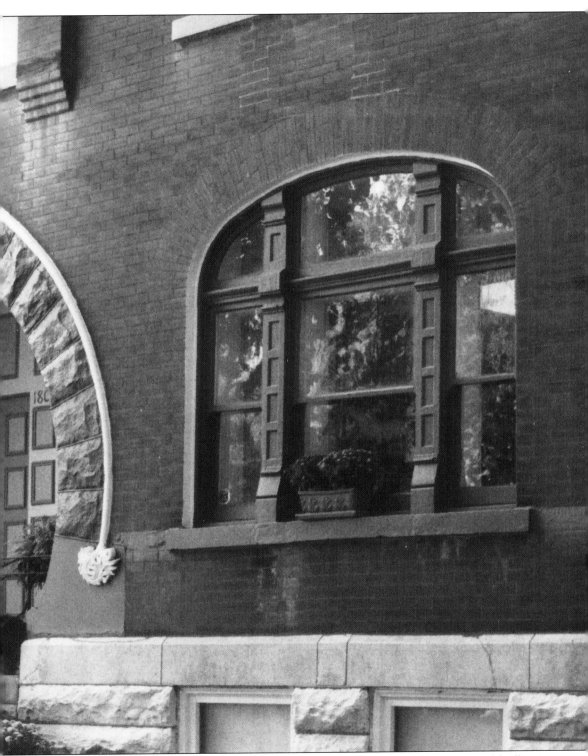

current owner and his partner, this expansive home has become a showplace of brilliant designs and collections.

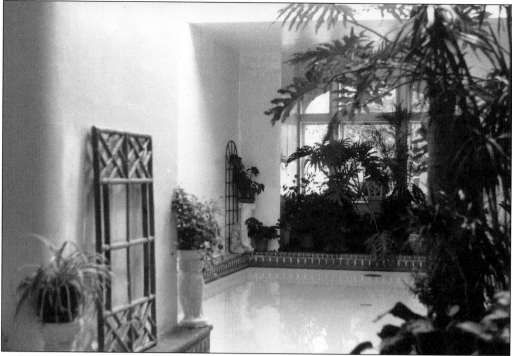

Included in this fashionable setting is a swimming pool built into the house's first floor or west wing. On occasion the pool is illuminated by candles set adrift on the waters. The effect is a pleasant display of light and shadow.

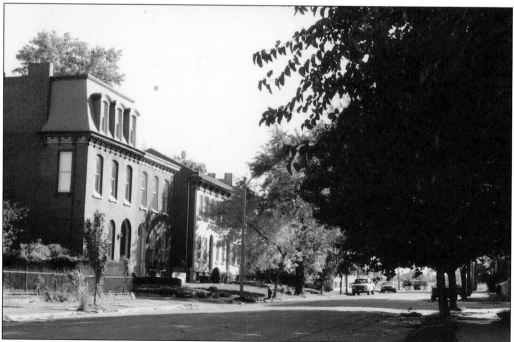

Pictured here is Eighteenth Street as it is caught in the stillness of a Lafayette fall afternoon. The Square is a pocket of quietness and serenity as traffic is modified on its streets.

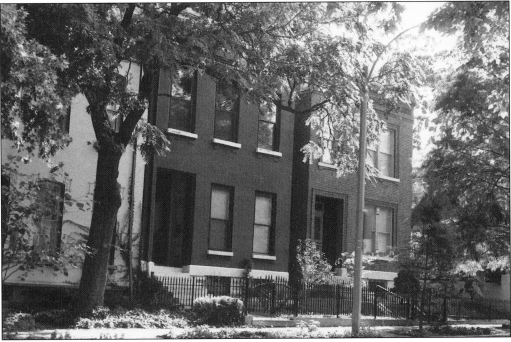

A line of South Eighteenth Street residences depicts the landscaping of yards and paths.

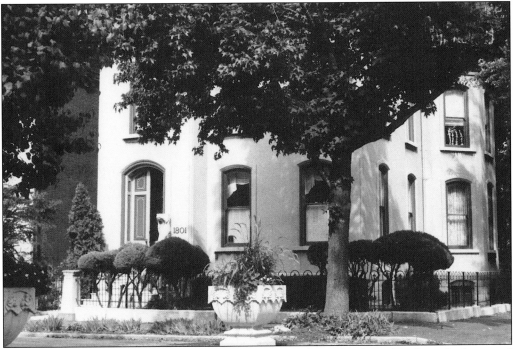

This house, at the corner of South Eighteenth and Hickory, has been handsomely decorated by Robert Cassilly, who once lived there. He added several sculpted pieces to the building to provide it with grace and authority.

In order to divert traffic away from the Square, various barriers have been erected to prevent any movement. Pictured here is a set built at the end of Eighteenth Street.

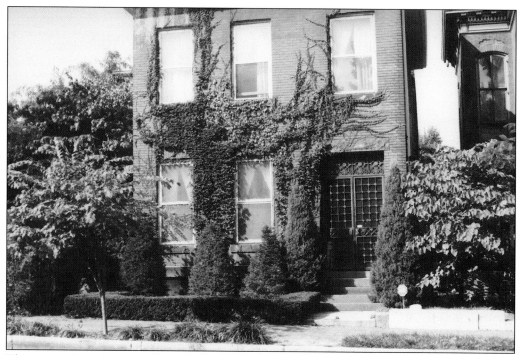

This restored residence on South Eighteenth catches the eyes of visitors immediately. It is the symmetry of house, landscape, and entranceway that attracts them. The house has a clean linear beauty that is gained by its arrangement of vine, door, hedge, and trees.

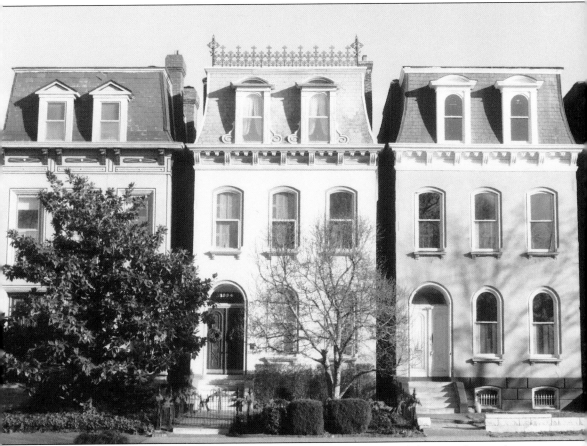

Notice the iron grill work atop the middle house. This was a special feature of many homes of the period.

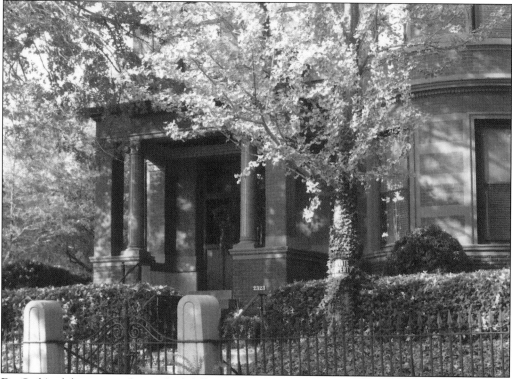

Dr. Seib's elaborate residence, faithfully maintained throughout the years, is shown here facing the busy Lafayette Avenue.

Dr. Seib's enormous garden is pictured here at full bloom.

Eight

Places of Interest

This rather imposing structure has worn many hats. Rebuilt near the site of the old Union Club, this building has been used as a German Club for many years. It is now owned and operated as the Gateway Temple and the Gateway Temple School.

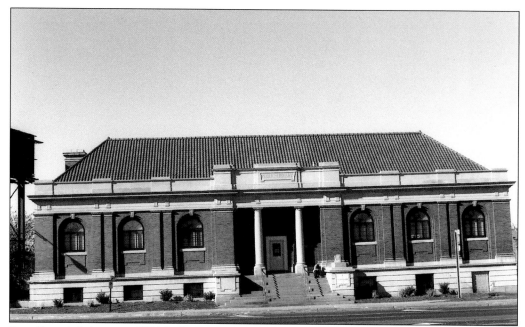

Barr Branch Library at 1701 Jefferson has recently been remodeled to suit the tastes of a new clientele, principally the children of the area. However, its basic classic shape has not in any manner been altered. It remains, as it was originally, a handsome Victorian building.

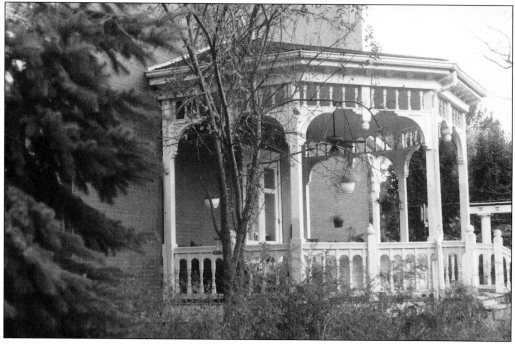

This photo depicts the lovely gazebo porch that is attached to the grand mansion at 2018 Lafayette. Fully restored to its original state, one can envision long-skirted women taking tea there.

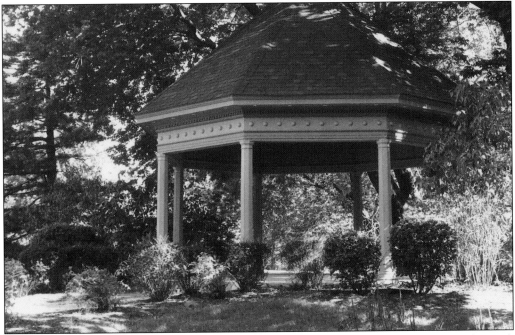

This gazebo is now used as a performance stage for the summer concerts held in the Park biweekly. Young people frequently desire to be married in its enclosure, and on occasion poetry concerts are held there.

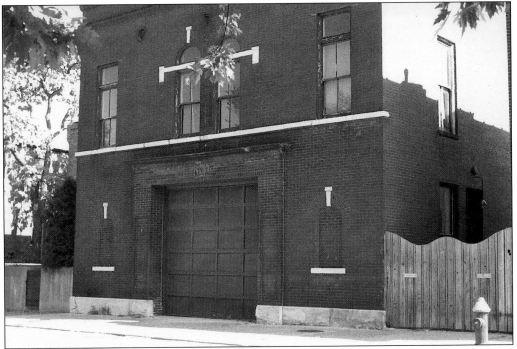

This ancient fire station on Lafayette near Jefferson must have guarded over the whole Square in its day. It sits as a reminder of its dutiful past while a bright new station on Jefferson takes over its old tasks.

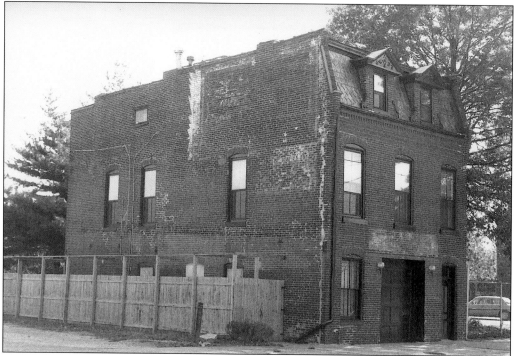

This was once an old livery station on South Eighteenth near Park, which has been remodeled and converted into a residence. A faded but enduring paint sign on its side still proclaims to the world that it once stabled horses.

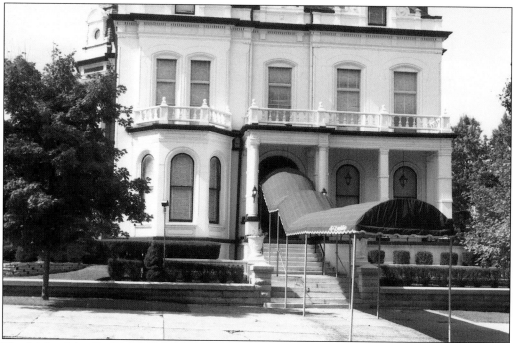

The Mclaughlin Funeral Home at 2301 Lafayette was partially destroyed by the 1896 tornado. When repaired, its architectural style was altered from the Italianate to the Romanesque.

The Gateway Christian school is located on the corner of Lafayette and Mississippi. This portion of its system is devoted to the education of the very young. The section in the old German house is for older students.

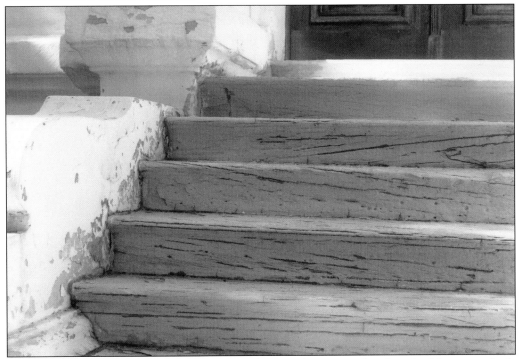

This set of stairs, unconquered by time, stands as a silent reminder that the Victorians built things to stay.

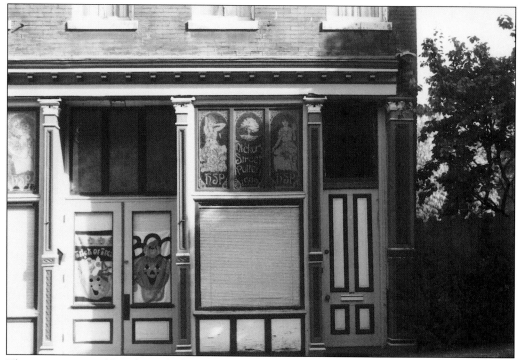

This attractive and handsomely decorated building houses the Hickory Street Art Gallery.

This gap in the street on Mississippi near Chouteau reveals that a streetcar once ran down this street.

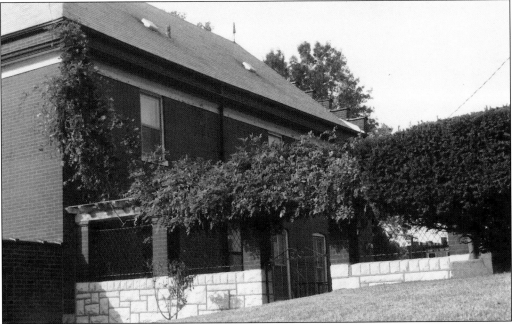

Decorated with flowing vine, this arcade connects the main building at McLaughlin Funeral home to its outer quarters.

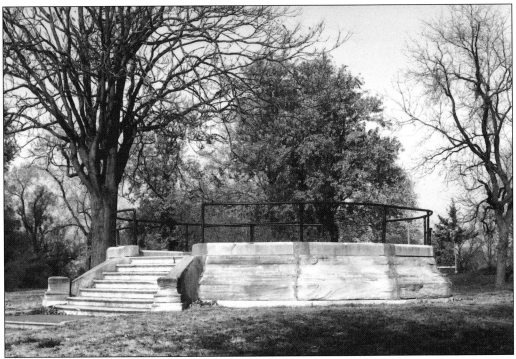

Pictured here are the remains of the once active band pavilion in Lafayette Park. The structure has not yet been restored from the brutal tornado, but plans are underway to rebuild it in the manner in which it once stood.

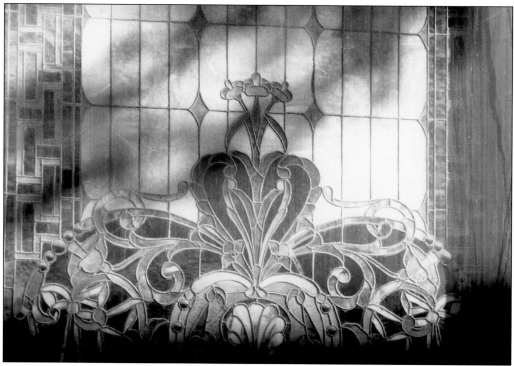

The elaborate and handsome stained-glass window at 1838 Kennett was cut into the side of the house and adds much charm to the exterior.

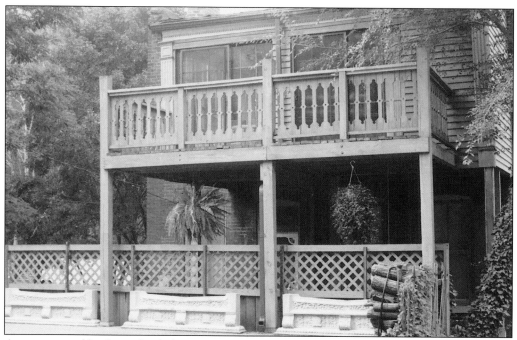

An ornamental back porch of a home on MacKay has been built by a recent owner. Its contours, coloring, and shape exude the ambience of a Victorian creation.

This courtyard was created by the famed local sculptor Bob Cassilly at a students' sports bar at the corner of Eighteenth and Park. At one time, there was a fountain built on its sidewall that spouted a flowing stream, but this was covered over to the regret of some customers.

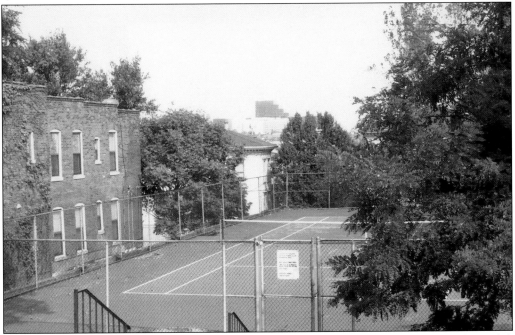

With the arrival of new people in the Square, inhabitants sought to create a modern club that would provide them with a few amenities. This resulted in the bath and tennis club built near Park Avenue.

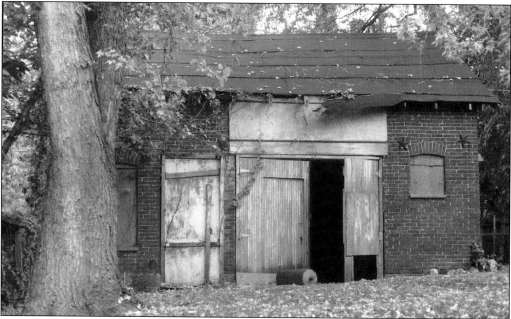

Visitors to the Square might wonder what this old shed was used for; it may have housed a horse, an automobile, or perhaps winter supplies. It remains today as a remnant of a storied past.

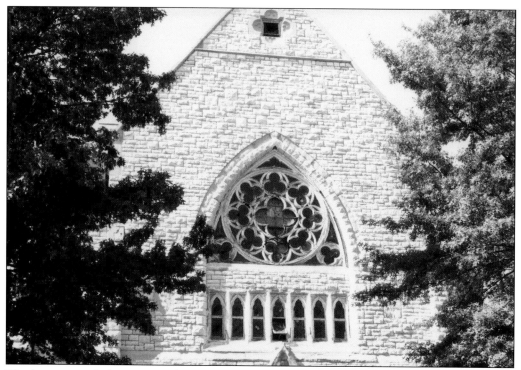

This large stained-glass rose window in the Lafayette Park Presbyterian Church, so badly damaged by the tornado of 1896, was created as a donation. It was given by Bredell, the owner of a vast tract of land on the south side of the Park, in memory of his son, who died in the Civil War.

Nine

CHURCHES

As this survey has occasionally shown, during the tornado of 1896 several of the Square's churches were severely damaged or partially destroyed. One of these stood then, as it does now, at the corner of Mississippi and Lafayette. The Lafayette Baptist Church was not long in restoring its severed self, and since that time of recovery the church has played an important role in the community.

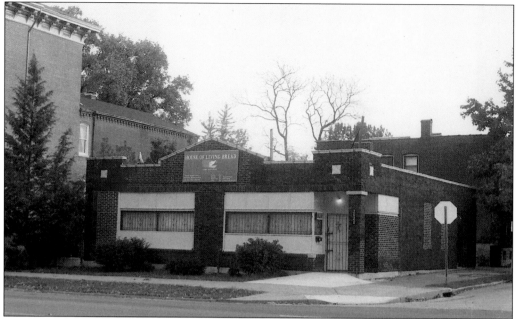

Converted now by the Agape Church into a place of worship, 2026 Lafayette has become an important locale in the community. The building was formerly used for purposes of commerce.

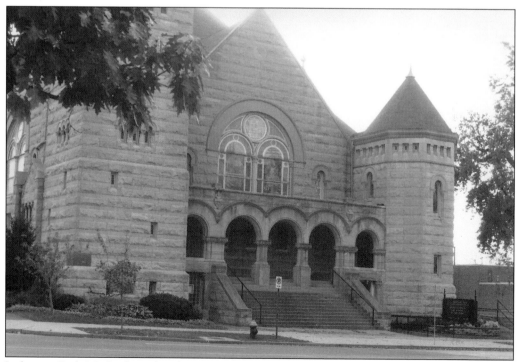

Lafayette Park Methodist Church, in ruins after the tornado, was rebuilt soon afterwards. Like many other structures in the Square, which were remodeled to a new architectural style, the church added an additional section, a hall magnificently paneled in rich woods.

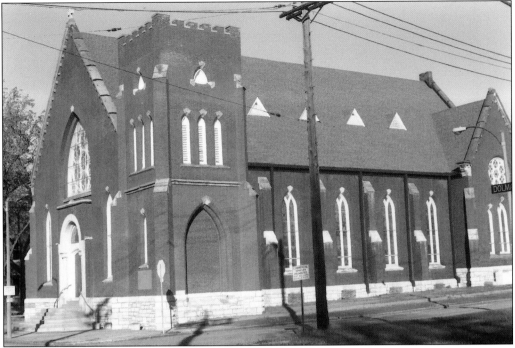

This church at Dolman and Hickory has undergone many religious owners. Bought some years ago by the Metropolitan Church, it was recently restored as a Catholic church. The new Catholic owners are also "rehabbing" the old church rectory, which has lain in ruins for years.

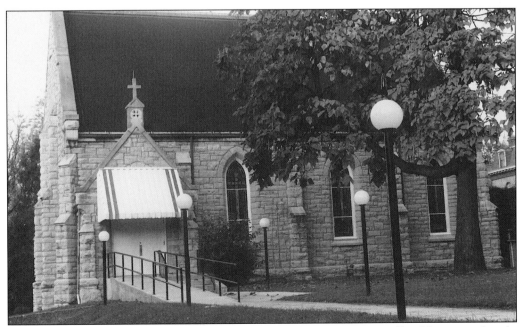

The Full Gospel Assembly Church of the Unity on Park Avenue, originally a Unitarian church, celebrated its first service on Easter Sunday in 1870.

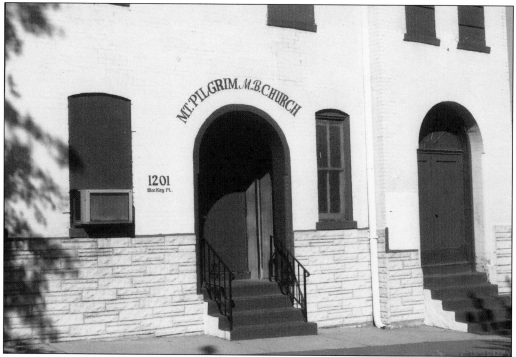

The Mount Pilgrim U.R. Church at 1201 Mackay has long been a part of the Lafayette Square community.

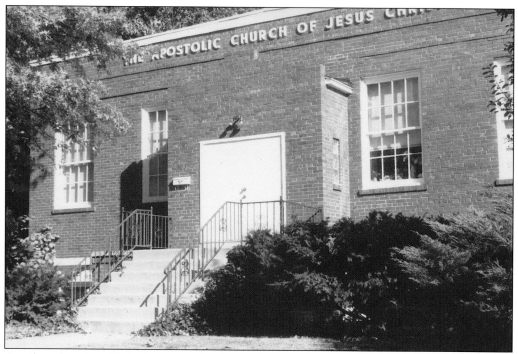

Another church on Park Avenue is the Apostolic Church of Christ at 2035 Park.

Ten

ARTISTS AND GALLERIES

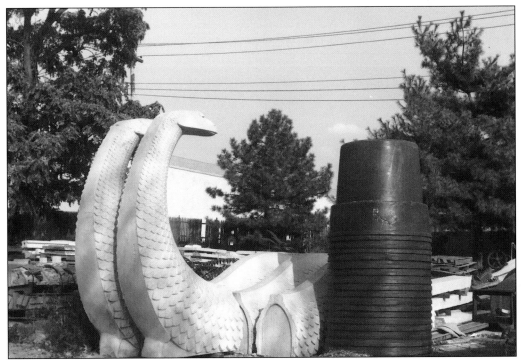

Two of the most creative and community-minded members of the Square are the sculptor, Robert Cassilly, and his wife, Gail. This couple has given themselves so completely to the city and the Square that they could easily be dubbed "Mr. and Mrs. St. Louis Restored." They have not only built a city museum in downtown but have contributed various sculpted pieces of rare beauty to the town at several locations. Pictured here is a whimsical creation of Bob Cassilly at his studio-factory on Lafayette Avenue.

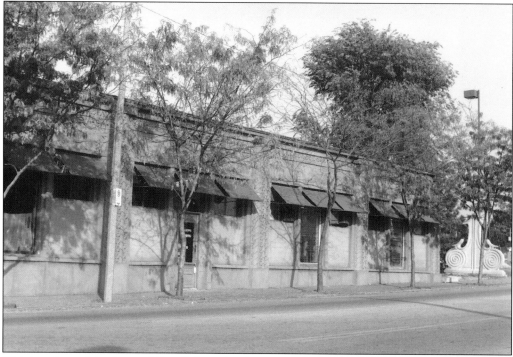

This is a shot of the front of Cassilly's studio-factory on Lafayette near Jefferson.

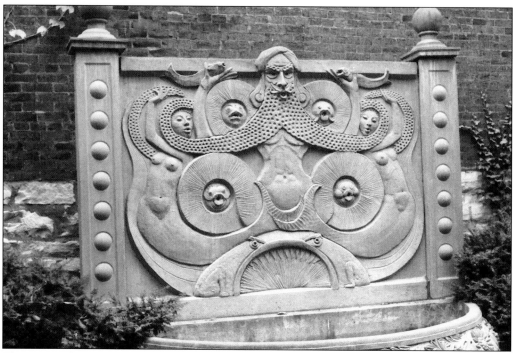

This particular art object can be found with several others in the Cassilly home on Hickory Street. It has been placed in the front entrance garden of this structure, which was once an Episcopalian mission house.

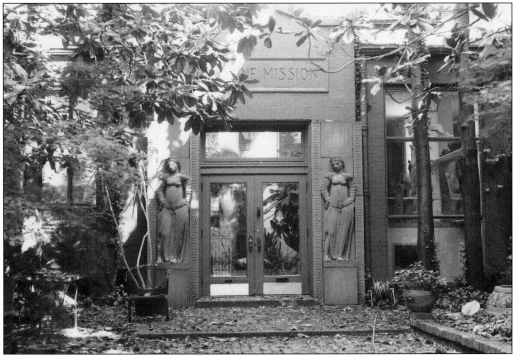

A front view of the garden entrance itself shows an array of sculpted pieces that have been carefully placed amid shrubbery and flowers, which makes for a picture of real beauty.

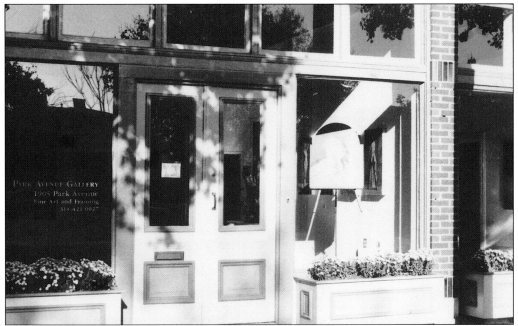

The Square is fortunate to have two art galleries in its midst, one being of international significance. The second is a newly opened venue called the Park Avenue Gallery. It is one of the cluster of business shops and stores that front Park Avenue between Mississippi and Eighteenth. Jeffrey L. Moore is both its owner and manager.

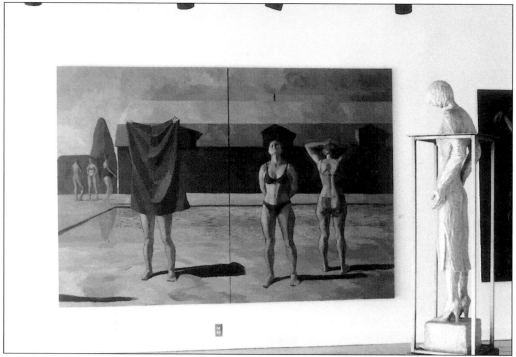

A recent exhibition at this gallery featured the work of Jeffrey Haupt, who lists his show as "Recent Paintings." Pictured here is one of the entries in this collection.

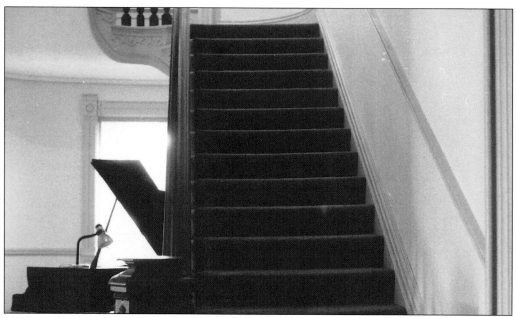

This graceful stairwell in the Austral Gallery was resurrected from its barren state by Mrs. Brunstrom, the owner, who labored over the house's restoration for many a year. The end product is a dwelling and gallery of exquisite taste and conception.

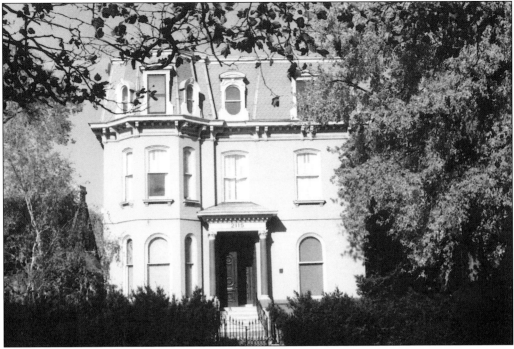

The Austral Gallery at 2115 Park is of some importance to Australian artists as its curator-owner Mary Brunstrom provides the artists with a venue in the United States where they may show their work. Works by other artists, local or national, are also featured on occasion.

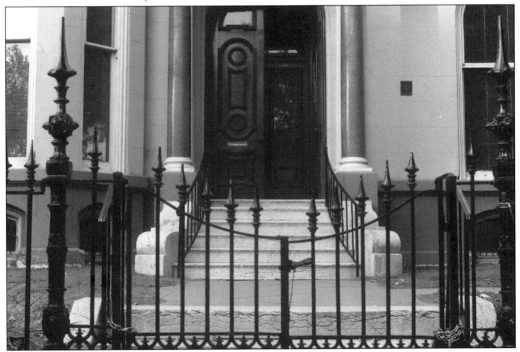

This Victorian iron-gated entrance to 2115 is a residual reminder that this home was originally designed by the famed George L. Barnett, whose work adorned the period.

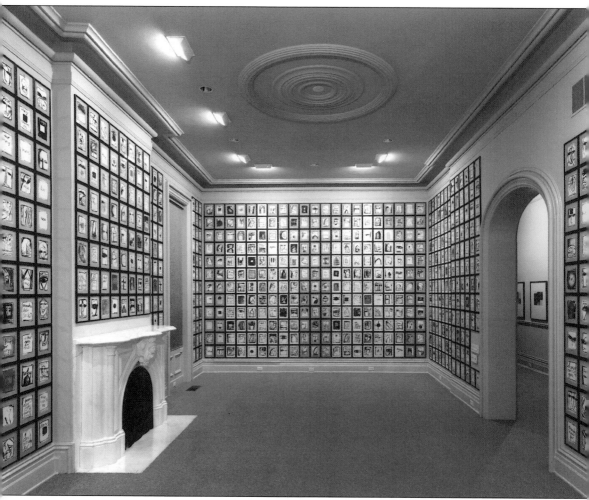

In this showroom, Mary has gathered together photographs and art pieces that have appeared in an Austral show. Note the handsome marble fireplace in the room's center that provides relief in its white simplicity to the colors on the wall.

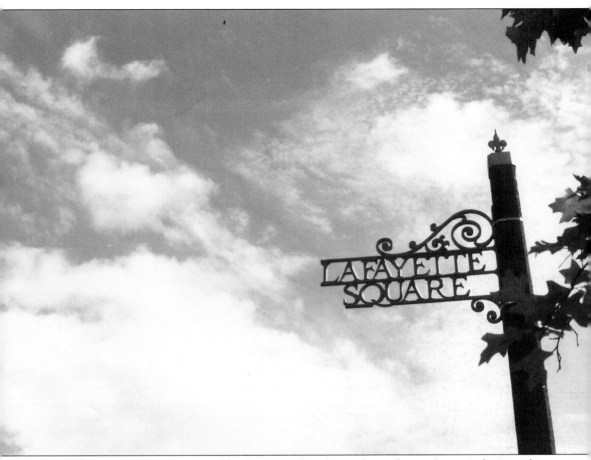

It seems fitting to close our survey of the Square with a photo of one of several signs indicating the new presence in an old neighborhood. Symbolically it stands before a backdrop of threatening cumulus clouds as if to say stormy days are behind.

BIBLIOGRAPHY

Sisters of Notre Dame Photographic Collection.

Mercantile Library Photographic Collection.

St. Louis Public Library Photographic Collection.

Issues of the *Marquis*, the Lafayette Square Newspaper.

Bryan, John Albury. *Lafayette Square*. Landmarks Association of St. Louis Press, 1969.

Conley, Timothy G. *Lafayette Square: An Urban Renaissance*. Lafayette Square Press, 1974.

Corbett, K. and H. Miller. *St. Louis in the Gilded Age*. Missouri Historical Society Press, 1993.